THE STORY OF
LANCASHIRE
COTTON

THE STORY OF
LANCASHIRE
COTTON

Ron Freethy

COUNTRYSIDE BOOKS
NEWBURY BERKSHIRE

First published 2011
© Ron Freethy 2011

COUNTRYSIDE BOOKS
3 Catherine Road
Newbury, Berkshire

To view our complete range of books,
please visit us at
www.countrysidebooks.co.uk

ISBN 978 1 84674 266 8

Designed by Peter Davies, Nautilus Design
Produced through MRM Associates Ltd., Reading
Printed by Information Press, Oxford

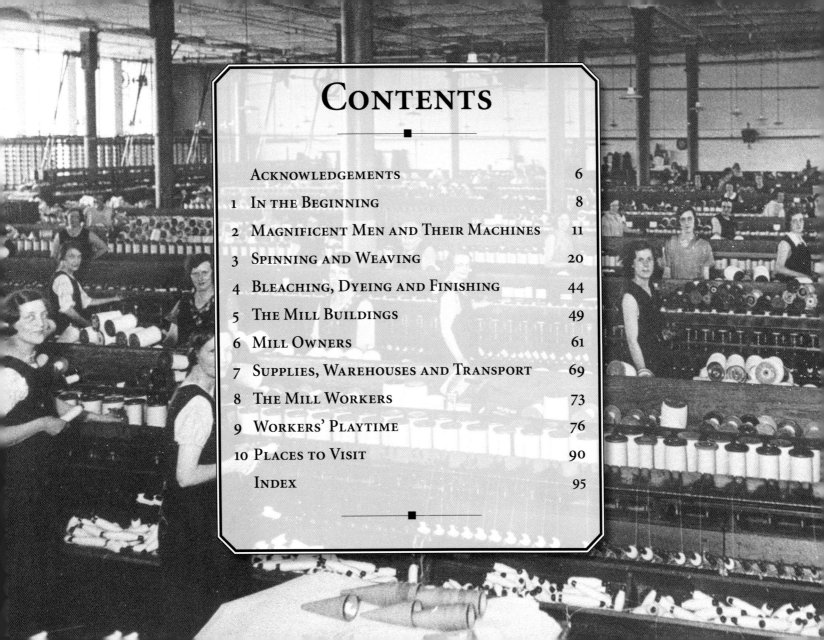

CONTENTS

■

■

ACKNOWLEDGEMENTS

NO BOOK CAN BE PRODUCED without the author asking for and getting help from other people. Many have given me assistance but there are some who have been especially important and to whom I would like to extend special thanks.

Firstly to Keith and Mary Hall who live in an old handloom weaver's cottage in the idyllic village of Downham. Apart from providing a regular supply of tea and biscuits, Keith has shared with me his collection of postcards and books relating to the history of the cotton industry and to Lancashire in general.

My wife and I also live in an old mill worker's cottage in the Pendle area and my next-door neighbours are Margaret and Roy Hope. They worked in the cotton industry for around 40 years and Margaret read my early drafts and looked at the illustrations which ensured that I made fewer errors.

I am also grateful to many helpful museum curators, especially Ian Gibson at the Helmshore Mills Museum complex and also Conrad Varley who operated at Queen Street Mill at Harle Syke near Burnley. Conrad put me in touch with Arthur English and a group of ex-cotton workers based in Trawden, near Colne. These people were literally mines of information. I also spent some time with the members of the Bacup Natural History Society better known as the 'Bacup Nats' which was founded in 1878. The Society has hundreds of photographs relating to the town and the local coal mines and cotton mills.

Apart from speaking to workers in the mills, I met several times with Adrian Mitchell who still owns Musbury Mill which is now a textile shop.

My main source of information was Peter Hargreaves whose ancestors can be traced back to the days before James Hargreaves developed his Spinning Jenny. Peter provided me with lots of images and as Margaret Hope worked in Moscow Mill, which is now the Oswaldtwistle Mills Shopping Complex, she was able to identify many of the workers shown in the photographs.

There was a real problem sorting out the illustrations and for this I required lots of assistance. As ever, my wife Marlene stepped in. She especially enjoyed the task because cotton is in her blood. Her ancestors can be traced back to the days when the Huguenots brought their textile skills to Britain as they fled to prevent religious persecution by the Catholics of the Low Countries.

Finally, any errors which may be discovered are due to my own mistakes and I welcome feedback, as well as any additional memories from readers. The history of Lancashire's cotton industry should never ever be forgotten and I hope that this book will add a little to its story.

Ron Freethy

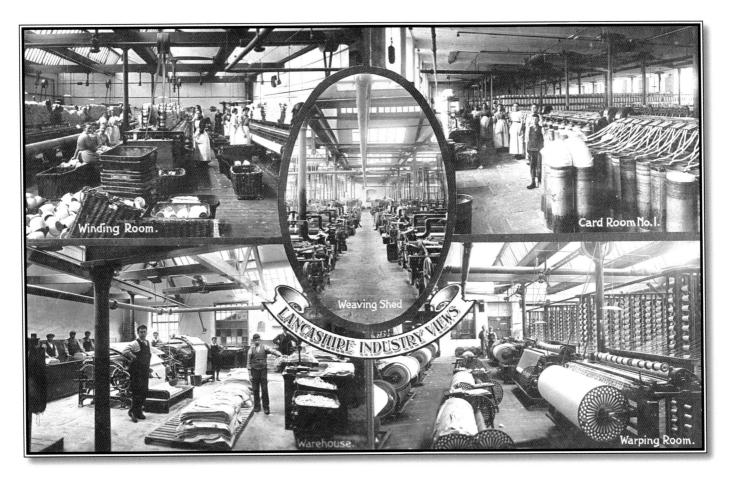

■ *Some of the processes carried out in the cotton mills, as shown on this postcard c1910.* ■

IN THE BEGINNING

■

IT IS STRANGE THAT the massive industrial empire based in Lancashire depended upon a plant called cotton which does not even grow in Britain. It was the inventiveness of the machine makers and the power, firstly of water and later steam, which drove the industry ever forward.

Botanists describe cotton as a genus of *Gossypium*, placed in an order of plants called the *Malvaceae*. To the industrialist the interest and the vast fortunes made from it lie in the fruit of the plant which is called the 'boll'. The feel of this in the hand is just like that of a featherweight ball of cotton wool which is exactly what it is. Within this cotton 'wool' and protected by it are the seeds. These seeds are very rich in oil and can be pressed to produce blocks of what is known as 'cotton cake'. When there is a shortage of grass, this cotton cake can be used as a winter cattle food.

The first cultivation of cotton seems to have taken place in the Indian sub-continent around 500 BC. Its people became skilled at both spinning and weaving and their cotton textiles were much sought after. From India the cultivation of cotton spread throughout Africa and may even have penetrated into the warmer areas of Europe.

In Europe the legend of the 'Vegetable Lamb' was once considered to be a fact. This postulates that there was a tree which produced a fruit which could be cut open to reveal

'*Withine a lyttle Beasle in Flesche in bone and blode as though it were a lyttle lamb with outer wolle*'. The legend included the startling fact that once the lamb was eaten the wool could be made into cloth! The relevance is obvious because of the remarkable resemblance between the bursting cotton boll and the wool of the sheep. Even to this day we refer to cotton wool, a product which is in demand by the medical profession and which also has more general uses.

Italy seems to have been the first area to commercially produce cotton-based fabrics sometime during the 13th century but there was soon a trade in England as religious refugees fled from Europe via Holland. The quality of European cotton at this time, however, was poor since the workers lacked the experience and expertise which had developed over thousands of years in the Indian sub-continent.

The quality of Indian cotton goods very soon became apparent when the East India Company began to import finished cotton in the 18th century. As the British influence increased all over India, especially in early Victorian times, cotton imports were more and more in demand.

The marketing of cotton in Britain was initially fraught with problems. The efforts of Europeans to copy the craft and nimbleness of the Indians were, to say the least, a miserable failure. The British attempts to produce cotton fabrics resulted in a very poor quality which few, if any, merchants would buy.

There was also a further problem because those who were making a fortune from wool and linen goods did not welcome those who were trying to produce cotton ones which could be

■ *Workers at Stanley Mill, Burnley, in the 1880s. The mill manager was Jimmy Jaques, seen third from left on the top row.* ■

both more versatile and also potentially much cheaper. These pressure groups had enough influence in Parliament to have laws passed which actually imposed fines on those convicted of wearing cotton gloves and, at one time, it was a penal offence to be buried in anything other than a woollen shroud!

Plainly the rules precluding the production of cotton goods could not continue. The price of linen was always high compared to cotton and the great mass of people were then,

as now, very price-conscious. In 1736 Parliament passed the first law which relaxed some of the conditions relating to cotton; it became legal to wear any type of fabric composed of a mixture of linen and cotton and which was manufactured in Britain. The stipulation was that the warp of the cloth had to be composed entirely of linen. Soon there was a further compromise which stipulated that the wearing of half Indian cotton and half linen flax apparel was legal. The immediate effect of Parliament's action was to give a tremendous impetus to cotton manufacture and for two centuries resulted in Lancashire becoming known as the 'Cotton Capital of the World'.

In the beginning, though, the industry was not much more than a handcraft and the methods employed in Lancashire were basically the same as those familiar to the cotton workers in India. Each Lancashire weaver's family was a small and separate entity: the weaver's wife and daughters (spinsters) carded and spun the raw cotton into yarn. The father and sons worked their heavy and cumbersome wooden handloom, and the finished fabric was then carried to a central point to be sold to a merchant. These central points were known as piece halls.

At this time the handloom weaver's cottage was literally dominated by the huge loom which demanded great strength and dexterity to operate and it had to be kept in good working order. This was the family's most valuable asset and hence the machine was passed on from father to his eldest son; we still use the word 'heirloom'.

There was some degree of industrial development even at this stage, though, because there were merchants who provided the raw materials and would buy the finished fabric. The price they paid was calculated by quality and length. Each length was called a 'piece' and thus we have the origins of the phrase we use to this day – 'piece work'.

Soon the demand for cotton goods exceeded supply. This provided an irresistible incentive for industrial development and what historians now call the 'putting out system'. The essence of this was that ambitious handloom weavers, or more likely merchants, combined to develop a production line.

Benjamin and Robert Walmesley were two brothers who were part of this system. They converted a couple of barns at their home in Rough Hey between Accrington and Blackburn into warehouses. Local weavers would visit these barns to collect raw cotton and then deliver the finished pieces to the accounts department. The family had to travel to Liverpool to collect the raw cotton from the docks and then to Manchester to sell on the pieces. This cannot have been easy in the 18th century when they used their horses and carts on roads little better than dirt tracks.

It was not long before the Rough Hey operation failed to keep up with demand and it was at this point that human inventiveness began to make its presence felt. From the mid-18th century, 'Magnificent Men and their Machines' evolved into one of the largest industrial complexes to be seen anywhere in the world. These efforts have been well chronicled in statistics and academic words but often lacking are memories dredged from the recollections of families and a supply of associated images. This is the subject of the next chapter.

MAGNIFICENT MEN AND THEIR MACHINES

■

IN THE BEGINNING, IT WAS WOMEN who did all the hard work. The heavy shuttles which carried the weft across the warp were thrown to and fro by a team of two. This meant that it was only possible to weave cloth to a maximum width of the length of the operators' outstretched arms. Then, in 1733, John Kay, the son of a wool manufacturer in Bury, invented the flying shuttle which signalled an industrial revolution in the textile industry. This flying shuttle returned automatically and so only one person was needed to operate the loom. The shuttle fired back at speed and thus weaving became faster which put extra pressure on the spinsters. Kay's invention in turn created a greater demand for weft which was at the time spun in a single thread operated by a treadle-operated spinning wheel, of different designs.

These early inventions were not popular with the spinners and weavers who viewed these machines as threats to their livelihoods and some were deliberately wrecked. This and legal actions with regard to patents led Kay to flee his home town and he died in poverty in France.

James Hargreaves (1720–1788) who lived at Stanhill, between Accrington and Blackburn, was another inventor who had to face these rioting mobs. James was one of the ablest weavers and craftsmen in the area. The cottage in which he lived and worked still stands; until recently it was the local post office but this has now closed and is a private residence, though there is a plaque to mark the site.

For more years than either of us cares to remember, Peter Hargreaves, a descendent of James Hargreaves, and I have enjoyed discovering more and more about the history of the Lancashire cotton industry. Peter has traced his family as far back as the 15th century and even at this time they were weavers. James Hargreaves is by far the most famous of the family and his journey through life was far from smooth. James built a spinning machine, which initially allowed one operator to spin eight threads simultaneously.

He called his machine the Spinning Jenny but historians now disagree with regard to the origins of the name. Most have suggested that the ground-breaking invention was the result of a fortunate accident when James's wife, Jenny, overturned her spinning wheel and its rotation gave the inventor his idea. This, I think, does the man less than justice because his inventive skills had already been recognised by the Peel family who were his more affluent neighbours. The latter were already amassing a fortune from their textile printing companies and, with their encouragement, James Hargreaves's fertile brain was constantly at work. The result of these combined incentives was the production of an eight-spindled machine. In the Lancashire dialect, machines were often referred to as 'jinnies' so the machine we now refer to as the

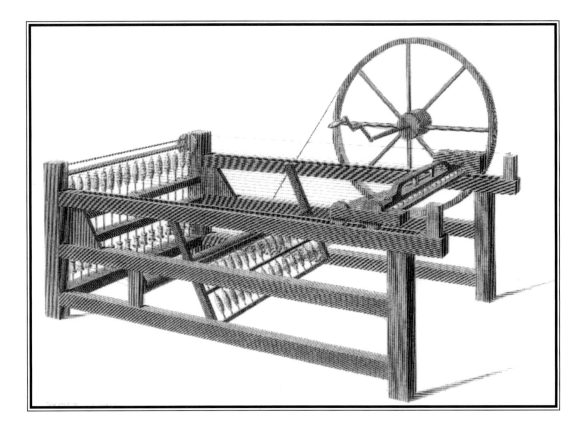

■ *Hargreaves's 'Spinning Jenny' which changed Lancashire's landscape forever.* ■

spinning jenny may well have first been called the spinning 'jinny'. There is a road close to Pendle Hill between Roughlee and Newchurch which is called Jinny Lane and indicates the presence of an early cotton factory.

One would have thought that Hargreaves's machine would have been welcomed but quite the reverse was the case. As with the flying shuttle, James's machine aroused instant antagonism among the spinning families who were

convinced that their livelihood was at risk. They rioted, raided workshops and destroyed any machines which they found. This was easy to do because the early machines were made of wood and were very fragile pieces of textile equipment. James Hargreaves found that even the lives of his wife and family were under threat and he fled to the relative safety of Nottingham.

The first seeds of the Cotton Revolution fell on stony ground but a few germinated and the rest, as they say, is history. The ground swell of machine-making was too important to be disregarded and, in the face of much opposition, the jenny was soon adapted to take as many as 80 threads at once. It rendered the household spinning wheel obsolete for all time as a commercial undertaking and thus began the movement away from the humble family cottage and into the cotton factories.

The next step in the mechanisation of the cotton industry was made by a man who hailed originally from Preston but who had a barber's shop in Bolton. I have read books which describe Richard Arkwright as an illiterate and simple barber but this is an insult to the genius of a man who was not just a barber but a very skilled wig maker. The services of a wig maker were very much in demand during this period of history and Arkwright was a wig maker with a difference. He toured the villages of Lancashire buying human hair and would visit the cottages of the handloom weavers and watch the spinsters at work. When he came across an

attractive head of hair, he would buy these locks knowing very well that every penny which came into these humble households would help to sustain the hard-pressed family. He also listened to his customers and realised just how labour-intensive spinning was and how difficult it was to produce enough thread to keep the increasing number of looms in full working capacity. No doubt he also listened carefully to the men who were discussing the new fangled machinery.

Arkwright, perhaps more than any other single individual,

■ *Arkwright's barber's shop in Bolton. The premises still stand and are almost opposite the modern offices occupied by the Bolton Evening News.* ■

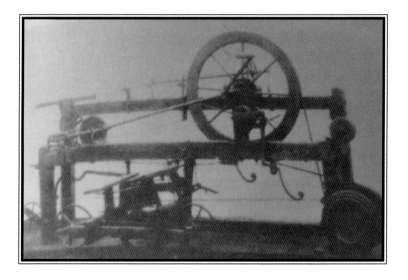

■ *Samuel Crompton (left) and his ingenious 'Mule' (right).* ■

used his inventive genius and a degree of industrial espionage to develop cotton into Lancashire's most famous and lucrative industry. With the financial support of a number of astute and far-sighted businessmen, Arkwright produced a frame on which the whole process of spinning could be carried out. This machine was also the first to produce a yarn which was

strong enough to be used for the warp as well as the weft. From the day that this machine was perfected, English calico could be made entirely of cotton with no linen incorporated. As a direct consequence, the fabric plummeted in price and the demand was insatiable; Arkwright's fortune was assured.

It is often stated that this was Richard Arkwright's sole, though vitally important, contribution to the history of the cotton industry. This is very far from the truth, however, because he made refinements to this first basic machine which meant that it could be adapted for carding and drawing cotton. As with Kay and Hargreaves, however, Arkwright's innovations were not universally welcomed. For a while he had to move away from Lancashire to Derbyshire where he established a huge complex at Cromford.

The final touch needed for the complete mechanisation of cotton spinning was provided by the genius of Samuel Crompton (1753–1827). He combined the spinning jenny with Arkwright's water-powered frame to produce a workable hybrid. This became known as the 'Mule' and it produced not only a fine yarn but it was also very strong and capable of being used for both the weft and the warp.

By far the best place to discover Samuel Crompton's place in textile history is to visit the Hall i' th' Wood museum on the outskirts of Bolton, off the road leading towards Blackburn. It must not be inferred that this splendidly-appointed, half-timbered mansion was the ancestral home of a rich family called Crompton. In the 18th century the hall, which literally was once in the middle of a wood, was all but derelict and was divided into rented tenements, of which one was the home of Samuel and his widowed mother.

The young inventor was faced with two very real threats: he was poor and his machine was being spied upon by unscrupulous businessmen eager to copy his machine before it could be completed and patented. Samuel obtained funds for his invention by making his own fiddle and playing it in local orchestras for a fee. His precious machine he stowed away in an attic and kept it under cover at all times when it was not in use. Such was the quality of his yarn, however, that it soon became known to his many and more affluent rivals.

Crompton's mule was so efficient that it was adopted very quickly and resulted in a huge surge in cotton goods' production. Unlike Arkwright, however, Crompton failed to combine his skills of invention with any semblance of business acumen. As a result he never became rich or able to develop his own industrial empire.

In the five years between 1787 and 1791 the imports of raw cotton into Britain leapt from 9,000 tons to 15,510 tons, an increase of around 80%. For the first time the Indian sub-continent and the West Indies were unable to supply the demand for raw cotton and cultivation spread to the southern states of America where growing conditions proved to be ideal.

The James Watt steam engine was another invention, vital to the developing cotton industry. This led to steam power replacing water power and thus meant that cotton production became freed from the geographical constraints of having to be located close to fast-moving water. It also meant that work didn't have to stop when there were periods of drought or an extended period of frost.

■ *The early mills were built in valleys so as to be near a water supply, as here at Darwen. Only later, with the advent of steam power, was there a shift away from the rivers. With the coming of steam, towns like Darwen became dominated by cotton factories, each with its own 'smoke poke' or chimney.* ■

Many of the old water-powered mills were simply converted to steam as was the case with the Narrowgates Mill in Barley, the Ellenroad Mill at Milnrow and the Primrose Mill at Clitheroe. Readers will no doubt add their own discoveries to this list. The main thrust, however, was when steam-driven cotton 'mills' could be built in the heart of the fast-developing cotton towns. Running costs were slashed and there was a rapid re-location of family workers from the countryside into the new towns.

Until this time, the only clothing material within the financial means of most people was woollen 'stuffs', often called 'Linsey Woolsey'. Linen was so highly-priced as to be completely beyond the means of all but the well-to-do. The garments worn by working people were never washed and were usually quilted. They were worn until they dropped to pieces, by which time their state of filth is better left to the imagination rather than described in detail. The state of their clothes set the whole standard of cleanliness – or perhaps lack of cleanliness – for what was described at the time as the 'lower orders of society'.

So, when cotton goods became cheap as well as plentiful, it resulted in a dramatic change in people's personal hygiene. Cotton clothes could be washed an infinite number of times, dried quickly and retained their colour so the logical next step was to improve bodily cleanliness to match the freshness of the clothes. The 19th-century historian Sir Walter Besant summed up the situation at the time when he wrote *'Civilization in fact largely depends upon the possibility of wearing cheaper garments which may be washed.'*

Those who read the works of Marx, Engels or Dickens will

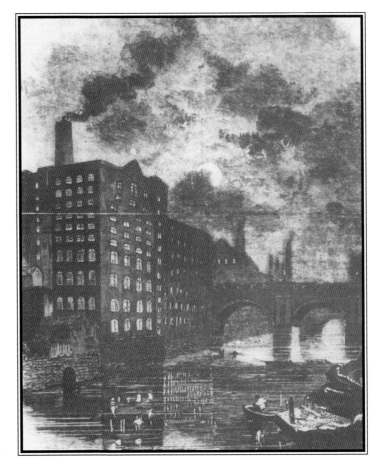

■ *A scene from the 1850s, showing smoke belching from the mill chimneys alongside the River Irwell in Manchester which, at the time, was an open sewer.* ■

gain the impression that all the working class lived in filth and squalor but this is far from the whole truth. Whilst it is true in some cases due to the cramped working conditions surrounded by belching chimneys which were at one time called 'smoke pokes' and the fact that there was no sewage system, not all workers in the cotton belt were so badly treated. This distinguished trio of writers were recording scenes similar to a print showing Manchester at the worst of times. To misquote Dickens, these were not only the worst of times but there were also traces of the best of times.

Many of the developing mill towns had their cotton factories surrounded by the houses in which their workforce lived. These terraced houses are still with us today in towns such as Bury, Bolton, Blackburn, Burnley, Nelson and Colne, plus Oldham and Rochdale to mention just a few. The workers who lived in these terraces close to the mill were proud of their houses which, in some cases, were more salubrious than the countryside dwellings in which they had lived for centuries. Floors were kept polished, windows cleaned, outdoor privies white- or lime-washed and even the front door steps were scrubbed using a brush and a donkey stone.

Mill workers wore cotton garments which were regularly washed and ironed. They owned and used dolly tubs, possers, wash boards and flat irons which were in evidence until the 1960s but are now relegated to craft museums thanks to the advent of cheap washing machines. Monday was washday and this was done early before the mill chimneys were fired up. Lines of washing fluttered like bunting in the slightest of breezes and a good blow dried the garments quickly. Many houses had drying contraptions in their kitchens called racks. These were wooden structures on a rope and pulley suspended from the kitchen ceiling and a wooden clothes horse was placed in front of the fire during wet weather. This wooden clothes horse had a second use; it was used as the frame for the children to make a tent!

The pioneer of the power loom which replaced the handloom in both the cotton and the woollen industry was without doubt Edmund Cartwright (1743–1823). He was born in Nottinghamshire and his father was a wealthy landowner and was able to send young Edmund to Oxford University where he became a churchman of Lincoln cathedral. He was a man with a very inquisitive mind, however. In 1784 he visited Cromford and looked at Arkwright's spinning machines. Cartwright was determined to produce a similar automated loom and although he was somewhat ridiculed because of his lack of experience he set to work with a will. He was able to patent his power loom in 1785 and although it was, to say the least, crude, it did work – at least sometimes! He made a number of versions and set up his own factory in Doncaster but he was no Arkwright in terms of business and in 1793 he was declared bankrupt.

Because of these and later inventions, mill-town life evolved and continued in Lancashire into the 1970s. Here were men and women with cotton in their fibres: spinners, weavers, drawers, twisters, printers, carders, rovers, tacklers, scutchers, slubbers, winders, warpers, slashers and a host of other skilled operators.

■ *Mill folk, especially the girls, took a pride in their appearance. They wore shawls and clogs and, until the First World War, many went to work wearing a straw hat. This rare and rather faded photograph shows the mill girls of Burnley c1900.* ■

SPINNING AND WEAVING

■

THE JOURNEY UNDERGONE by a boll of cotton to become part of a piece of fabric is one of quite remarkable proportions. During its passage it is processed by an impressive array of huge and powerful machines, each requiring the supervision of workers. In the early days, these steam-driven machines were watched over by an army of men, women and children. Just like in the days of the cottage spinning wheel and the handloom, whole families were employed in the cotton trade.

The cotton, in bales each weighing between four and five hundredweights, arrived in the port of Liverpool where it was sampled and graded by skilled sorters, and then inspected by the spinner who purchased what he needed.

On arrival at the mill the bales were opened by removing the protective jute covers. A number of bales were then placed in a high stack called a mixing. In the mixing process, the cotton was blended to give the desired colour, strength and quality of the thread.

After being blended, the cotton was passed through a

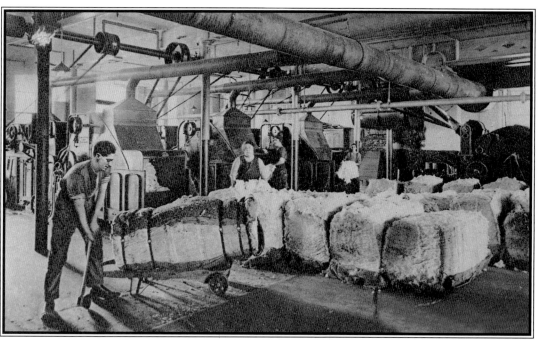

■ *Getting ready to break up the cotton.* ■

number of processes to cleanse it from the impurities which it contained in the form of sand, seeds, leaves and bits of cotton, which could not be worked and which were called 'neps', and to allow it to be arranged in a more convenient and portable form. This produced an atmosphere full of small fibres of cotton dust and all those who worked with cotton had to live – and sadly sometimes die – from breathing this dust into their lungs.

Opening was the first process of cotton production. Here the cotton was turned into light flakes by rapidly revolving beaters, and carried over a series of grates by a current of air which forced the cotton fibres to 'float'. The heavier impurities dropped in the grids and the cotton passed forward to the principal opener beater.

The **Principal Opener Beater** was literally a shaft carrying many blades, also called arms, surrounded by edged bars of iron. This beater revolved at around 1,000 times a minute and it is obvious from this that the machine had to be both powerful and strong. Any additional 'lumpy' impurities in the cotton impinged on the edges of the bar and were thrown out when the flaky fibres were passed forward in the current of air. These fibres were then collected by a series of rollers and formed into a sheet, which was then converted to a roll, approximately one yard wide and forty yards long. Each piece was known as a 'lap' which could then be further processed.

However efficient the opener machines were, some foreign matter still remained within the lap and the 'sheet' might not be regular or even enough to satisfy the cotton spinner. The function of the **scutcher** which was termed the 'breaker' and the 'finisher scutcher' was specifically designed to overcome these defects. Three or four laps were placed so that they unfolded together on a revolving lattice. This carried the cotton into a beater, which was a two-bladed blunt knife, revolving at around twenty-five times a second. The beater also dashed the cotton against a series of edged bars, which further separated the seed from the finely divided flakes.

The **Finisher Scutcher** worked on the same principle and further refined the cotton. An ingenious apparatus to secure evenness was attached to these machines. If the laps as they unroll at the back of the machine are too thin, the lattice automatically begins to move more quickly, and thus feeds the machine with the correct weight of laps.

Carding was the next and most important of the earlier stages in cotton spinning. The rolls of cotton from the scutcher are at the back or feed end of the card. This feeding is done slowly and the cotton is immediately seized by a roller covered with wire teeth, and moving in continuity to a large cylinder, covered also with lots of wire needle-like points. Between the two the cotton is separated fibre from fibre, and in that state passes forward to a series of 'flats' which are, in essence, broad comb-like structures made of steel. Between the teeth of the cylinder and the teeth of the flats the cotton is combed out in order to lay the fibres parallel, and also to cause the remnants of dirt which it still contains, such as leaves and naps, to become trapped in the interstices. Another cylinder then clears the cotton from the much larger main cylinder. At this stage, a riband of clean cotton is revealed and this is called a 'sliver'.

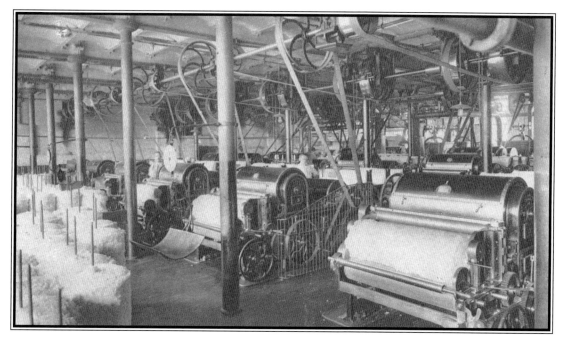

■ *Scutching frames, used to further clean the cotton of impurities.* ■

This carded cotton was acceptable to most mills but when extra high-quality yarn was needed, the carding process was repeated and this yarn was then referred to as 'double carded'.

Combing was an expensive and seldom-used process but was necessary when very fine yarns were required. This combing machine took over from the carded yarn and divided the cotton fibres and separated the long and short fibres. It was these short fibres which were used to produce the finest yarn.

Drawing is the process which followed the carding and, if needed, the combing. Here are three sets of machines which are similar to each other in construction and treat the 'sliver riband' consecutively. The first 'drawing frame' takes six slivers up and draws them into one by means of four pairs of rollers rapidly revolving at different speeds, the fastest being those that deliver the drawn sliver. By this process, any irregularity of thickness is neutralised by the fact that it is drawn through five additional rollers.

The foreign matter extracted from the cotton up to this point amounted to about 10% of the original bulk and thus the cleansing process ended. The huge carding engines which often produced clouds of dust were operated by men, whilst in the early days very young children were used as assistants. This was discontinued after the First World War and even then there were 'half-timers' who spent half the day at school and half a day grinding away at the mill for very little pay.

of rollers are again drawn and formed into one riband of fibres, now beautifully silky, even, parallel and as perfect as any machinery can ever make them.

There is great skill in the manufacture of such machines and each mill would have its own engineer capable of servicing the machines. It needed an observant eye to be kept on the 'drawing machine' whilst it was working. If any one of the six threads was broken, the machine would produce an uneven cloth which could never be sold. A most ingenious arrangement, however, stops the machine should any one of the threads break. If an insulating substance is placed between the ends of the

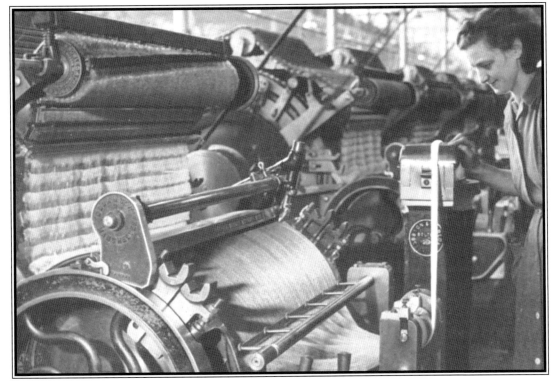

■ *The Card Room* ■

At the 'second drawing frame' six of the slivers from the first drawing process are passed through and drawn into one, for the purpose of neutralising irregularity and arranging the individual fibres into a parallel formation.

At the 'third drawing frame' six slivers from the second set

wires connecting the two poles of an electric battery, then the circuit is broken. In drawing frames one part of the machine is connected to one wire and the remainder to the other wire with a battery or magneto-electric machine. The thread of the cotton keeps the two parts of the machine from coming into

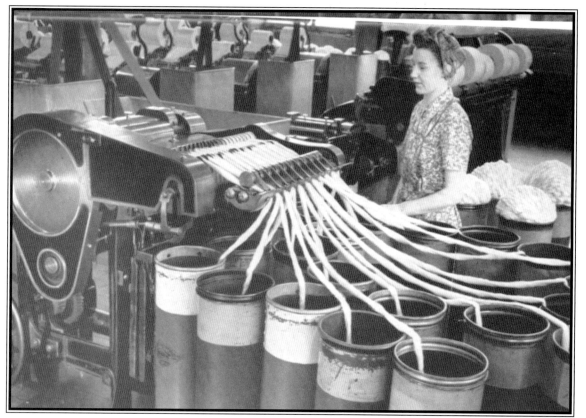

■ Operating a sliver lap machine. ■

At the end of the 'drawing' process, the cotton was coiled and placed in cans. These were then subjected to a further four processes leading to the production of a workable yarn. Three of these processes are slubbing, intermediate and roving. These so-called frames are all constructed on the same principle. They do the same class of work but they treat the material consecutively, so that it emerges much finer at the end of the roving process. There are lots of bobbins used in these processes and bobbin mills – one of the spin-off industries associated with cotton – were much in demand.

The continuation in each case is caused by three lines of double rollers through which the cotton passes; the contact, thus providing the insulator. Immediately any one thread breaks, the cotton is absent and the circuit reacts by shutting the machine down.

last pair revolve faster than the first and the sliver is thus drawn out. As it is drawn it is also twisted and wound onto a bobbin, the twist being imparted to it to enable the fibres to cohere.

The attendants working on these frames were all women and girls and their job was to keep each machine supplied with cotton, repair any breakages and to remove the finished work. They, along with the 'drawers' who attended the drawing frames, were called 'cardroom hands' and individually as 'rovers', 'slubbers' or 'intermediates', according to the work which they did.

The place where this phase of the work took place resembled a hospital as much as a mill. There were long rows of humming spindles and row after row of snow-white bobbins and even the attendants were clad in clean white uniforms. At the end of this process the cotton thread was ready for the spinning mill.

The casual historian is often mistaken into thinking that the production of cotton was just a two-fold process – spinning and weaving. As just described, there were eleven processes involved even before the spinning machines could begin to operate.

SPINNING

Even the inventors like James Hargreaves, Richard Arkwright and Samuel Crompton would have been amazed to see the huge machines which were soon humming away in hundreds of mills. First, mule spinning and, later, ring spinning made fortunes for a few and provided work for many.

THE SPINNING MULE

From the roving machine the cotton yarn was delivered to the spinning mule. Here, three pairs of rollers regulated by wheels could produce any size of thread. The thread then passed to the point of a spindle, of which there were one thousand placed in one row, set in a traversing carriage. These spindles, as the carriage moved outwards, revolved at the speed of 10,000 revolutions a minute, or 160 times each second, and twisted the threads into yarn as they revolved. When 60 inches of yarn had been spun, the carriage reversed its direction of motion, and the spindles, slowly revolving, wound on the spun yarn; this being completed, the carriage moved out and the spinning started again. In the case of most machines the whole of this process took about four minutes.

The 'cops' as they were called were used as either weft or twist. The wefts were smaller and ready for the weaver's shuttle. The twist was a much stronger yarn which passed through more processes before it was introduced into the fabric and used as the warp in the weaving process.

In our modern age where we have become used to small-scale operations, the sheer size and quantity of apparatus involved in the mule machines and the intricacy of its functioning are hard to comprehend. The mules were operated by men and in the early days they were accompanied by boys. The men spinners were the most prosperous of any of the mill operatives not holding a managerial position.

The fineness to which the cotton yarn could be spun was of great importance as profits were dependent upon the production of reliable quality. The fineness of yarn, known as 'counts' was indicated by numbers, the lower numbers

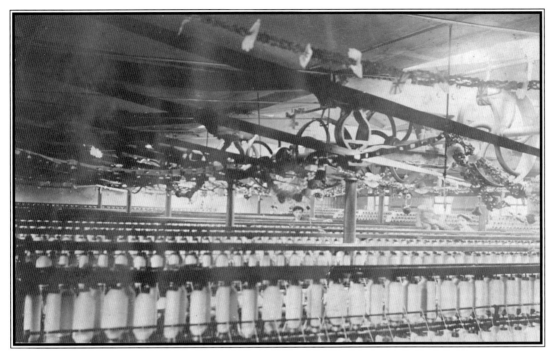

■ This huge mule spinning machine was operating in a Bacup mill in the early 20th century. It must have been a dangerous place to work, with miles of revolving belts and lots of moving carriages. ■

as an experiment could have produced 1,000 miles of yarn for one pound!

Ring Spinning was developed in America and parts of Europe but Lancashire mill owners were reluctant to convert. The huge number of mule spinning machines in operation had meant a great financial expenditure and any investment in new technology was viewed with some scepticism and worry. There seems to be no doubt, however, that ring spinning was a much more efficient method and therefore the machines were cheaper to run and to maintain.

In ring spinning there is no moveable carriage, nor is the spinning process intermittent as was the case with the mule. The ring frame has a system of a three-pair roller system of draughting, with the thread leaving the rollers passing through a small wire traveller which revolves rapidly around a ring, which accounts for the name of ring spinning. This arrangement twists the thread which is then wound onto

signifying thicker thread. The bulk of yarn for ordinary fabrics was between 32 and 42 counts. This meant that from one pound of cotton 15 to 20 miles of thread could be produced.

American cotton can be spun to 80 counts which means that there would be 38 miles for every pound. Sea Islands cotton has been spun to 2,150 counts and although only done

cotton spinning was carried out in lofty, very elegant-looking buildings, several storeys high. At the peak of affluence and ambition some of these mills were examples of Victorian splendour. In the early days those who worked in the mills, though, were mere chattels and young children were a source of cheap labour. As the 19th century neared its close, there was

■ *Mule spinning was dominant in Lancashire mills until the 1930s. Companies producing the machines were highly profitable.* ■

■ *A typical weaving mill, now demolished, at Ribchester in the Ribble Valley. Note the single storey sheds and the angled windows to admit maximum light.* ■

a ring frame bobbin. The bobbin on its spindle which revolves at high speed is actually the motor of the traveller. Girls attended to the ring frames and in a large spinning mill these workers were by far the most numerous in comparison with other operatives.

To secure the essential warmth, dryness and completeness,

■ *Ring spinning eventually came to Lancashire in the 1950s. Here is a mill lass hard at work at Waterfall Mill, run by William Birtwistle and Co.* ■

some government intervention limiting the hours of labour to ten hours per day and the 1872 Education Act meant that child labour was reduced although there continued to be some abuse of this until the turn of the 19th century. In 1910 the British Cotton Industry produced 480 million miles of thread per week which equated to two miles of thread per day for every man, woman and child in Britain!

The production of thread by the spinning mills, of course, provided only the raw material from which the textile could be woven.

COTTON MANUFACTURE – THE WEAVING SHEDS (MILLS)

Weaving was carried out in much less salubrious buildings and the sheds were low, with lots of sloping and angled windows to allow maximum light. These were designed in the days before gas light and electrical illumination.

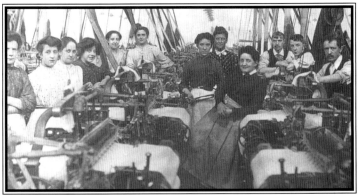

■ *Weavers at Walton's Mill in Hapton, c1907.* ■

■ *Before 1893 girls as young as eleven were allowed to work in a weaving shed but, after 1899, the age was raised to twelve.* ■

There was also a tendency to have part of the shed below ground level because the humidity was high here. This meant that the yarn was easier to weave and less likely to break.

The spinning process tended to be concentrated in the south of the county, especially around Oldham and Rochdale, but there were important spinning mills in other towns including Chorley and Bolton. Weaving, also known in its heyday as cotton manufacturing, was particularly concentrated in the north-east of Lancashire, around the Blackburn and Burnley areas. In these areas cotton yarn was converted into cloth.

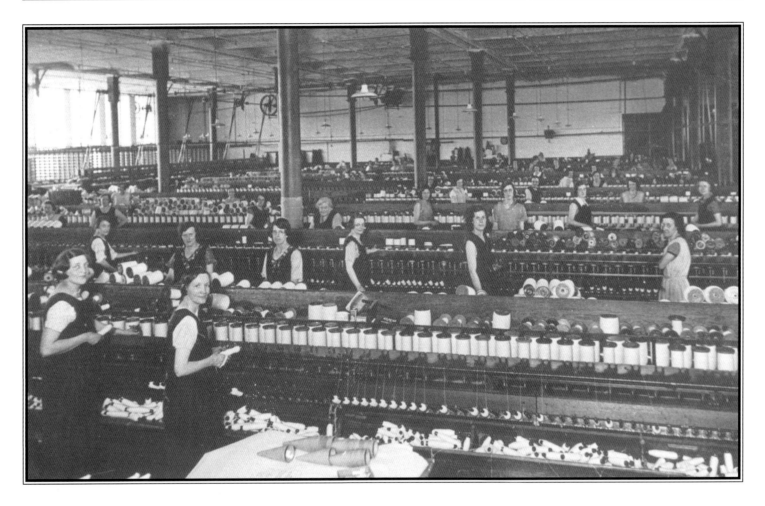

■ *The winding room at India Mill, Darwen, around 1920. Many mills were called India because most of their fabrics were exported to that continent.* ■

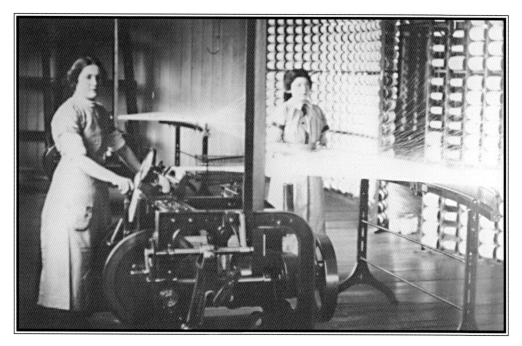

■ *Madge Bollon (right) at work at Meadows Mill in Bacup. She was aged 15 when this photograph was taken in 1910.* ■

a yard and a half wide with large flanged ends. The sheet of threads was then wound on the rollers, layer upon layer until ten or fifteen thousand yards filled the whole of the warper's beam. This is called beam-warping and was once considered to be one of the best-paid employments for women in the mill.

Once again, it was the case that if any of the threads should break, it meant a loss of time and this meant a 'loss of brass' to the cash-conscious mill owner. To prevent these breakages occurring during beam warping, a simple and cheap piece of equipment was invented. On each thread was hung a small bent pin, like a diminutive hairpin, and if the thread broke, the pin dropped between two rollers, and separated them. This slight movement stopped the whole frame until the end was pieced up. The operatives learned by experience to deal effectively with this problem very quickly.

Before weaving could take place, during which the warp in particular was subjected to severe strains and chaffing, it was essential to harden the threads by the application of a paste.

WINDING

When the yarn arrived from the spinning mill, the huge cops were wound onto large barrel-shaped bobbins, each having a capacity of about one pound of twist. This process was carried out on a winding frame and those who operated them – mainly women and, in the early days, girls – were known as winders. Tier after tier of bobbins were fixed onto the frame each containing about 500 bobbins.

The ends of the threads were then fed through a number of large combs and rollers to a circular wooden beam, each

*A sizing machine showing a weaver's beam containing the sized threads of yarn.
The operative shown in the photograph indicates the scale of the machines.*

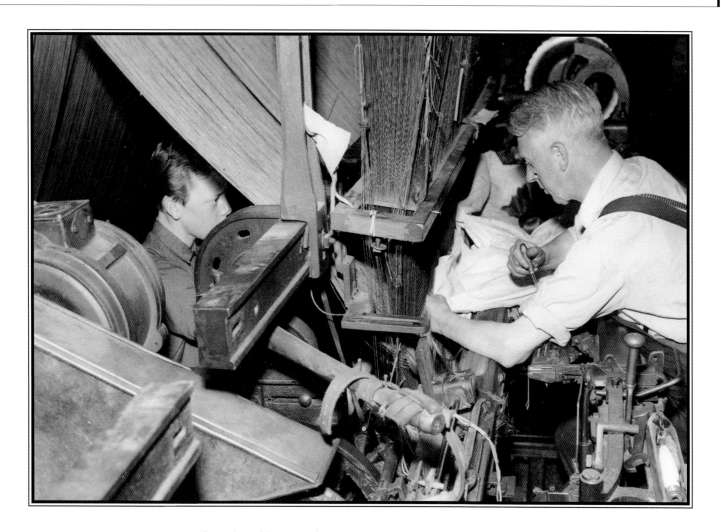

■ *Fred Cowburn 'drawing in' at Moscow Mill, Oswaldtwistle in the 1960s.* ■

■ *Dennis Wilson operating a knotting machine at Moscow Mill, c1970* ■

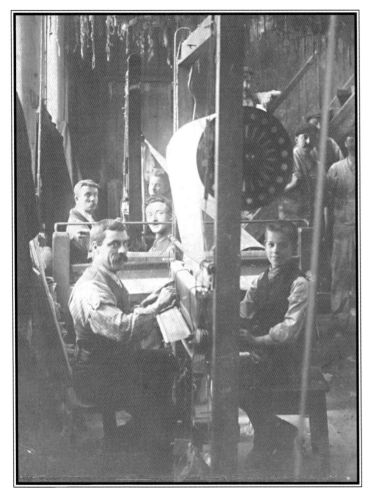

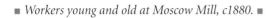
Workers young and old at Moscow Mill, c1880.

Several warpers' beams were collected and placed behind the huge slashing frame; the sheets of thread were passed from them to a trough of boiling liquid and immediately passed forward to two huge, slowly-revolving, hot cylinders. The cotton then emerged hot and dry. It was then wound onto a weaver's beam, a wooden roller with broad iron flanges.

The thread was now ready to be loaded into the loom, but care needed to be taken to ensure that the fabric feeding the weft was separated from that feeding the warp. This was done by men using an apparatus called 'healds'. These were merely rods carrying rows of 'eyes' through which the threads passed. If a plain cloth was required, then there were between two and four healds. If sateens were required, then five healds were needed and for spotted or figured cloths between twelve or fourteen of these 'eyes' were required.

Then followed a process called 'drawing in'. Here the threads from a weaver's beam are passed through these healds, with a man sitting on one side of the healds with a hook, drawing the threads through as they are presented to him, initially by a boy or girl 'reacher' on the other side. This process means that the beam is ready to be inserted into the loom. Many people not used to life in 'Cotton Country' think that the weaving shed is the start of the process to manufacture fabric whilst, in fact, this is the end of the very long sequence.

A phrase still in use all over Britain to indicate haste is 'get weaving'. As Lancashire cotton and Yorkshire wool began to dominate the textile industry worldwide, many thousands of these northern folk really did get weaving.

The very simplicity of the design was the strength of the machine which became known as the Lancashire loom, even though the many manufacturers devised improvements in both function and appearance. The three main operating sequences, however, have not changed at all over the centuries. These were shuttle flight; shedding which changed the direction of the thread; and then the third and final phase which was called the 'beat up'. In a good Lancashire loom this sequence was repeated up to 200 times a minute and was very noisy.

The 'shuttle flight' was called 'picking' and each loom had a picking stick; it is this which created the loud clicking noise. When a fabric was finished, the number of picks per inch was important and the lower the number of picks the better quality the fabric. Overlookers carried a small graded magnifying glass and learned to count the picks. Shedding is the process in which the warp is lifted to engage with the weft on the loom. The 'beat up' is the last stage and here the reeds push up the threads to solidify the piece.

The maintenance of the looms was the work of a tackler who was usually a promoted weaver and was an occupation reserved for men. The promotion from weaver to tackler involved an intermediate period of doing 'odd jobs' so that the man could get used to the geography and working of the whole of the mill. A good operator could be an established tackler whilst in his mid-twenties. A tackler's wage depended upon the total output of the mill and by this definition he had to be on the side of the bosses and in consequence was often disliked by the weavers. The latter, however, did respect a good tackler who kept their looms running as their wages depended upon piecework. The trust between the tackler and

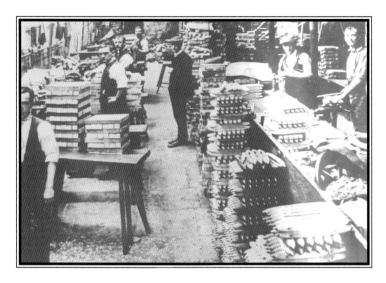

■ *Cotton mills demanded huge numbers of shuttles. This photograph shows the Kirk & Company works in Blackburn, c1900. Note the cap and suit worn by the foreman whose job it was to ensure that the quality of the product was up to standard.* ■

the mill owner can be realised by a recorded meeting between a tackler called Jim Catlow and the Burnley mill owner John Gray. When Gray was knighted, his tackler greeted him with the words *'Good morning Sir John'*. John Gray's reply was *'Now Jim, it's always been Jim and John between thee and me, and that's th' way is going to go on.'*

The weavers got used to their looms and when a mill owner began to set up his machines he had a wide range of models to choose from. There were many companies operating in

what was a very competitive business. Three of the most successful were Pillings of Colne, Platts of Oldham, and Howard & Bullough of Accrington. Not only did these firms produce Lancashire looms but also machinery associated with spinning.

In 1819, J. Pilling and Sons set up their loom works, foundry and textile mill and became so successful that in the 1850s they built a huge complex at Primet Bridge in Colne. It reached its production peak in the late 19th century and only closed in 1974. The site now produces kitchen furniture, and the building is Grade II listed which means that this piece of Lancashire cotton history will not disappear.

The loom manufacturing, foundry and textile mill was an integrated and well co-ordinated site where loom parts were forged, assembled and tested. Timber components were machined and metal castings were produced from molten iron from the foundry. Colne Water bounded the complex to the south, Greenfield Road to the north and Burnley Road to the east. The design of the complex was set around two large courtyards and the buildings consisted of an engine house, chimney, a smithy, a machine shop, offices and a series of weaving sheds.

Pillings concentrated their efforts on weaving but Platts were concerned with all aspects of the textile industry, especially spinning. They were also involved in producing machines for the Yorkshire woollen industry.

In 1821 Henry Platt had a factory at Dobcross in Saddleworth, but established himself in Oldham and later formed a partnership with Elijah Hibbert. The company was named Hibbert, Platt and Sons and eventually

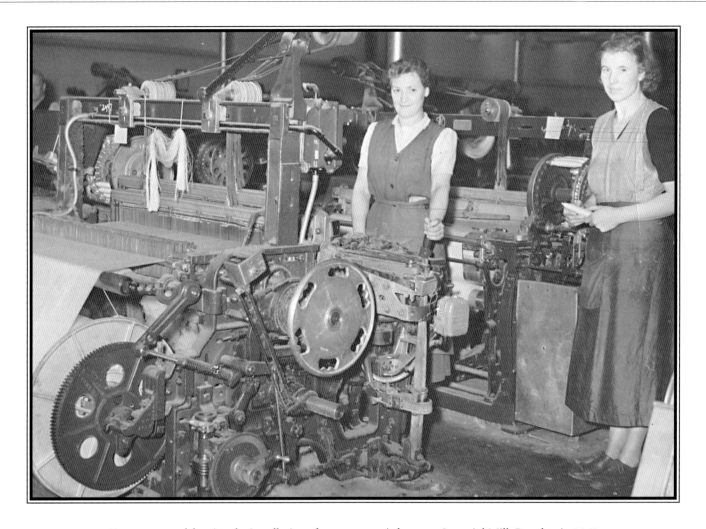

■ *Two weavers celebrating the installation of new automatic looms at Imperial Mill, Burnley, in 1963.* ■

■ *The famous Pilling-designed loom on display at Barden Mill, Burnley.*
This is one of several mill shops operating in Lancashire. ■

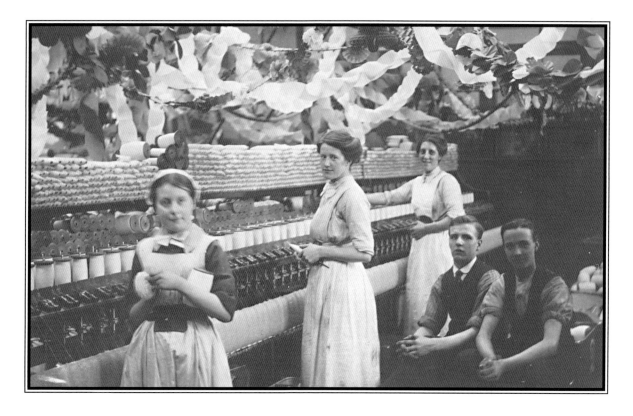

■ *Workers at Howard & Bullough on the occasion of a royal visit to the company by George V on 9th July 1913.* ■

employed 15,000 people. It is impossible to consider the history of Oldham without reference to this company which soon became famous worldwide. The company improved the machines associated with cotton spinning and perfected the carding machine, the roving frame and the self-acting mule; the latter was so good that it had no rival in the length and speed of its operation. Many people were employed and the partners made vast fortunes.

There was, however, always fierce competition and Platt's main rivals in 1896 were Howard & Bullough of Accrington,

Tweedales and Smalley of Rochdale, Dobson and Barlow of Bolton and, in Oldham itself, the firm of Asa Lees. The year 1902 was a peak year for cotton machinery production but in the 1920s and especially in the 1930s there was a serious slump. Platt Brothers amalgamated with Howard & Bullough, Brooks and Doxey, Dobson and Barlow, Asa Lees and several other companies. A new company called Textile Machinery Makers Limited was formed but the going was always going to be tough against foreign firms with cheaper labour costs. In 1970 another company was formed called Platt International which is still in existence and has a website reflecting this continuing, if diminished, industry.

Just like Platts, Howard & Bullough had an excellent reputation and was initiated by two men from Bury named Howard and Bleakley. In 1853 they had just four employees producing textile machinery and forged parts to keep old equipment working. There was, however a rapid expansion at their works in the Scaticliffe area of Accrington. In 1856 Bleakley pulled out of the business and James Bullough who was a very skilful inventor and engineer took over the business on his own. By 1864 the firm were well-known for the excellence of their Lancashire looms and expanded their business to make other machines. They also had a separate unit making shuttles.

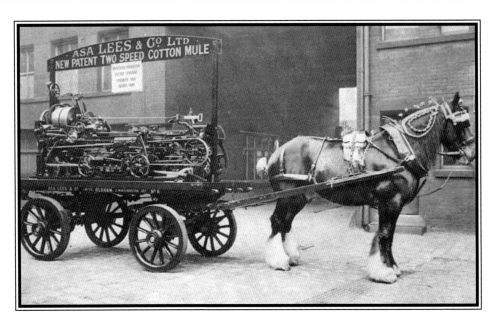

■ *Asa Lees was another company making cotton machinery.* ■

New premises were built in Chester Street and this occupied four acres. By 1930 the floor space spread over fifty acres and a network of train lines fed what had become known as the Globe Works. At this time Howard came into the company to control the finances and Howard & Bullough took its place in the history of cotton. At its peak the company employed more than 6,000 people. Without the Globe at that time, Accrington would have become a ghost town. In the Second World War, the Globe turned its attention to the production of aircraft components, shells and gun carriages.

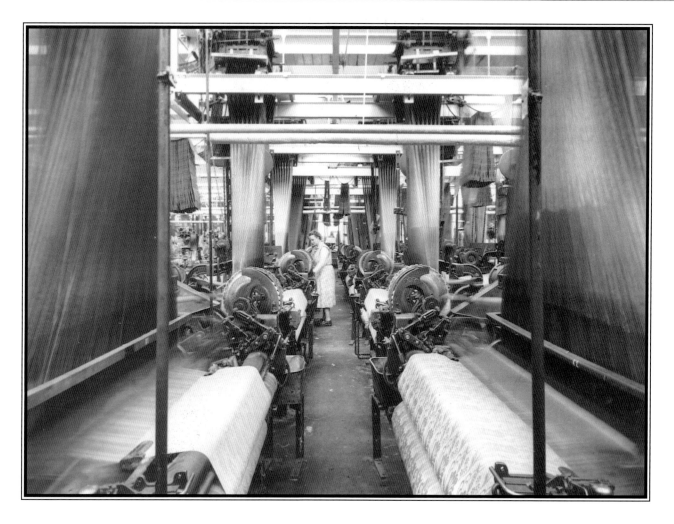

■ *Jacquard looms being prepared to weave patterns, using punched cards fitted to the looms – Moscow Mill c1970.* ■

As was the case with Platts and all other engineering companies, business steadily declined and, in 1970, the name Howard & Bullough disappeared under the heading of Platt International and in 1975 the company name changed again, this time to Platt Saco Lowell. Production, however, continued to decline and in 1993 the Globe Works closed. Today the Globe Centre, which is operated by the Hyndburn Borough Council, offers accommodation to local businesses and presently some 1,000 people are employed there.

The Northrop Company based in Blackburn produced a number of looms with variations suitable for weaving textiles such as poplin. ■

BLEACHING, DYEING AND FINISHING

■

ALL OVER LANCASHIRE there are public houses called the Printer's Arms and on OS maps there are references to 'print works'. There are some still operating such as those at Belmont, near Bolton, and another at Stubbins, near Ramsbottom. There are others long gone but whose reservoirs have survived. There are those at Foxhill Bank in Oswaldtwistle which is now a popular local nature reserve and another at Barrow between Whalley and Clitheroe. One of the ponds is now a trout fishery and the other situated close to the A59 has a circular walk around it.

The term 'print works' refers to the finishing process such as bleaching and dyeing which produced saleable cotton fabrics. The dyeing and printing of colours onto fabrics, as with the spinning and weaving processes, can be traced back to antiquity, but the Industrial Revolution and an associated scientific revolution meant the introduction of more sophisticated techniques involving larger and more complex machinery.

The earliest technique was known as 'block printing' and most scholars think that this was invented by the Chinese some 2,000 years ago. The block printer requires both skill and patience as each block can be used only for one colour. Each pattern has to be created by carefully measured wooden blocks and plenty of time has to be allowed for each colour to dry before another can be added to the pattern. The wood chosen for blocking includes box, holly, lime, sycamore, plane and pear, with the backing made from cheaper wood such as deal or pine. Each block is kept moist by covering it with a damp cloth to prevent warping. The tools used by the block printer include a colour sieve and a wooden mallet called a 'maul' but, prior to printing, the fabric's pattern is marked out using coloured chalk. The whole process is time-consuming and therefore expensive.

Block printing of cotton fabrics reached a peak not so much with regard to artistic quality but for sheer volume in Lancashire during the 19th century. It was at this time that hundreds of new print works were constructed, each with their own guarantee of a pure water supply. The blocks at that time were composed of several layers of wood glued together, with the grain running at different angles. The relief of the pattern meant that the hard woods were uppermost in the block; more patterns were developed by carving reliefs into the block.

The block printing works at Belmont near Bolton was built in 1800 by Thomas Ryecroft. He followed the Lancashire pattern by siting his works close to a stream in a valley bottom and thus ensured a ready supply of clean water.

Later developments included techniques known as coppering and felting. This involved fixing copper or brass strips to the block and, in some cases, attaching pins to the block to provide a stippling effect. With felting, the thick

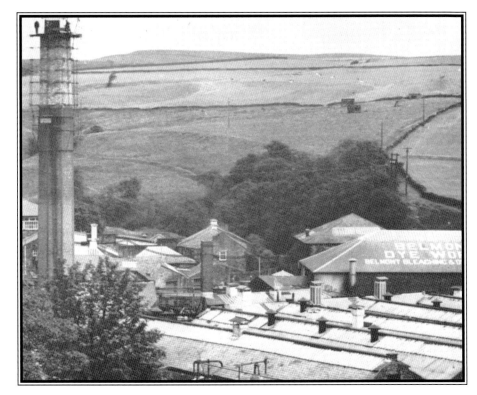

■ *Belmont Dyeworks, seen here in the 1960s.* ■

18 inches square (45 cms) and 2½ inches (6 cms) deep was regarded as a problem. Each printer had an assistant called a 'tierer', usually a young person or a woman.

In the case of Lancashire's expanding cotton industry, block printing was soon found to be too expensive and too slow and the manufacturers eagerly looked for mechanical innovations. One technique known as cylinder printing was initiated from 1750s onwards. The first successful machine was patented by the Scotsman Thomas Bell in 1783. This used what became known as the doctor blade which scraped the excess dye from a series of large rollers. The word 'doctor' was probably an adaptation from the word 'abductor'. Initially the rollers were made of solid copper but soon a shell was produced with a copper face which was both lighter and cheaper.

By the 1830s cylinder printing was becoming ever more popular, especially as the number of cylinders which could be used at the same time increased from only two or three to as many as twelve or even fourteen. There was a machine operating in the Turnbull and Stockdale works at Stubbins near Ramsbottom which had a machine capable of printing designs with up to fourteen different colours. In order to assure a colour consistency, there were very skilful men who were colour mixers and they worked closely with the

fabric was soaked in a mixture of water and gum which allowed much heavier colour deposits to be applied.

Hand block printing required attention to be paid to ensure that the size and weight of the block could be handled by the operator. Anything heavier than 10 lbs (4½ kgs) or larger than

designers, some of whom became very famous, even in the competitive art world.

The Lancashire cotton men obviously favoured cylinder printing which resulted in a much quicker turnover and substantially increased profits. At first the cylinders, like the wood blocks, had to be individually engraved but soon this could be done by machines. Prominent in this area was the Manchester firm of Joseph Lockett and Company who developed what became known as the mill and dye system. This involved a small cylinder-shaped die made of steel and which initially was hand engraved to a pattern agreed by the customer. This die was hardened and slotted into the mill which was also hardened and inserted into the roller. Once they had been engraved, the dies and mills were stored so that repeat orders could be speedily undertaken.

A further development became known as the 'pantograph' or 'pentograph' technique which transferred an image from a flat zinc or copper plate bearing an engraving which was then inserted into the cylinder. This process involved covering the cylinder with varnish and then transferring the pattern using diamond-pointed styluses laying bare the copper. This was then etched in permanently by means of nitric acid. At this stage the inventions made by chemists came into prominence. During the 1920s and especially during the depression years of the 1930s, attempts were made to 'process' cylinders using photographic techniques in order to dispense with all degrees of hand engraving but these methods were not perfected until after the Second World War.

Men like Harold Foote at the Woodnook complex in Accrington worked on and around these cylinder printing

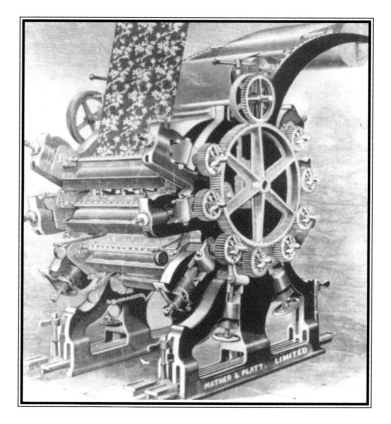

■ *A 1910 advertisement by Mather & Platt for their 12-colour cylinder printing machine.* ■

machines all his working life. When he retired in 1983 he had worked at Woodnook for 43 years. He started in 1934 at the age of 14 and earned 13s.11d. a week. At first he worked in the

bleaching croft but eventually rose to become the dye house foreman.

Each dye works had to ensure that the fabric was bleached before the coloured patterns could be printed. In the very early days, bleaching was done outside with the cloth pegged out on tenter hooks. This was a very slow process and frustrating for those waiting to print. We still use the phrase being on 'tenterhooks' to the present day whenever we are kept waiting. Bleaching was speeded up a little by using sour milk or even human urine. There was a system in Lancashire where people collected their urine and sold it to merchants who, in turn, sold it on to the bleaching areas which were known as crofts. As chemical knowledge increased, bleaching powder which is chlorine-based was manufactured and steam power allowed the bleached cloth to be dried quickly.

Screen printing was, in Lancashire terms at least, the pinnacle of the evolution of fabric finishing. As was the case with both spinning and weaving, the Lancashire cotton men were slow to take on new innovations during periods when recession was biting hard. Why, they argued, should they invest in expensive new machinery when their old machinery was working well and they had a skilled and experienced workforce to maintain their plant?

Gradually, however, flat screen printing was accepted which, in simplistic terms, is based upon a stencilling technique. The screens are just shallow trays with a metal or wooden frame between which is stretched a mesh of silk, nylon, or other man-made fibres. The design is applied to the stretched fabric and the dye squeezed through the pattern. The instrument used to squeeze the dye is a wooden bar with a rubber edge called the 'squeegie'. At first the machines were hand-operated but the screens became fully automated from the 1950s onwards.

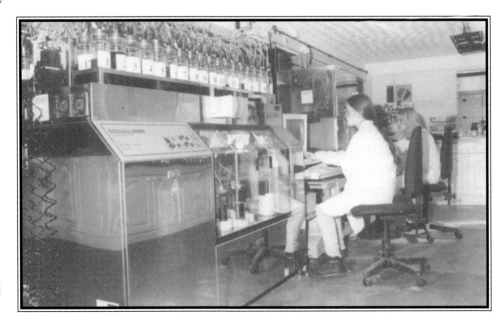

■ *The Woodnook colour mixing laboratory in 1997.* ■

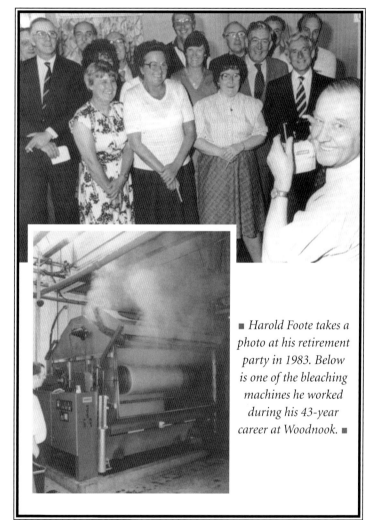

By the mid 1950s flat screen printers were being replaced by rotary machines. All these innovations meant that the fabric could be produced in greater volumes but the final finishing had to involve very careful drying and the process of 'stentering' which strengthened the fabric. Steam was the main drying agent and when viewed from a distance the printworks always seemed to be enveloped in steam, as opposed to smoke from a single chimney. The very latest stenter machinery dries the fabric using gas power but this method is becoming ever more expensive. A further development is the replacement of the colour mixer with a computerised system.

■ *A gas-fired stenter drying machine at Woodnook works, Accrington, in 1998.* ■

■ *Harold Foote takes a photo at his retirement party in 1983. Below is one of the bleaching machines he worked during his 43-year career at Woodnook.* ■

THE MILL BUILDINGS

THE WORD 'MILL' APPLIED TO COTTON is something of a misnomer and dates back to the days when corn mills were converted for the production of cotton and were usually concerned with spinning rather than weaving. These early mills were powered by means of waterwheels and most of these old waterwheels have long gone but several do remain. There are examples at Chipping near Preston and at Barrowford on the outskirts of Nelson, where there are plans to have the waterwheel restored to full working order.

There is plenty of evidence of long-vanished mills where the old waterwheel pits can still be seen. There are several along the Ashworth Valley between Edenfield and Rochdale and along the Brock Valley between Preston and Garstang; whilst there are others in the Pendle villages of Barley and Roughlee, with the latter having a waterfall which was actually a man-made weir built to accelerate the speed of the river current which powered the mill. When the Roughlee mill was converted to steam, a pond – known locally as a lodge – was dug and is now a trout fishery. At Clitheroe, the old Primrose Mill building is now used by a carpet company

Also at Clitheroe was another small water-powered mill, Low Moor, which was then converted to steam and around which, in 1799, Jeremiah Garnett built a village for the workers, one of several so-called 'model' villages that grew up around this time. In 1826 new power looms were installed at Low Moor and the local handloom weavers did not take kindly to this and began to riot. Garnett tried to anticipate this problem by constructing a moat around his property but this did not deter the rioters and he had to summon a troop of cavalry from Burnley to restore some sort of order. Eventually peace prevailed and the mill and its associated dwellings could continue working. In 1900 the mill employed 700 workers operating 1,160 looms. When the mill closed in 1930, there was great hardship at Low Moor which had at that time been largely self-sufficient.

The 'model' village of Calder Vale was begun as early as 1835 by the Quaker brothers Richard and Jonathan Jackson. They chose an area of the River Calder, a tributary of the River Wyre, set in a steep wooded valley. In time two mills were built, including the now ruined Low Mill. The four-storied Lappet mill, however, still works a 24-hour day and produces the red, white and black checked cloth which is exported to Arab countries and used for head wear. The Jacksons realised that there ever-increasing workforce would need to be housed and to have somewhere to relax. However, being Quakers, the brothers did not build a pub and to this day, there is still no hostelry in the village of Calder Vale.

This intermediate period when cotton production was moving away from small converted mills to purpose built factories can clearly be seen at Barrow Bridge, on the outskirts of Bolton. Unlike Calder Vale, no mills have survived here but the village is recognised by those who live there as a time-encapsulated reminder of the early days of the Industrial Revolution.

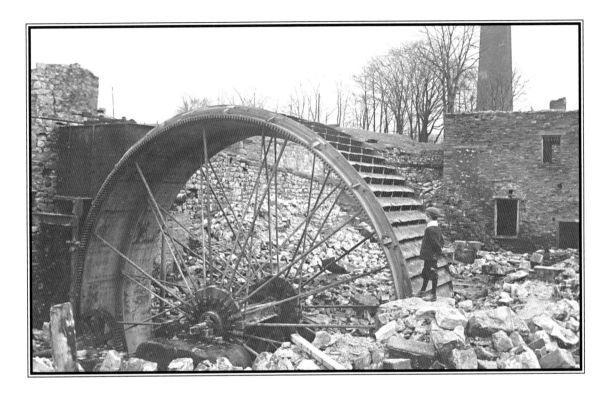

■ The old waterwheel being demolished at Primrose Mill in Clitheroe. ■

There had been a small textile mill on the site for some time when, in 1830, the complex was bought by Robert Gardner of Manchester who appointed a very able mill manager named Thomas Bailey. The partnership worked so well that profits soared and new mills were built. The management looked after their increasing workforce and provided them with pleasant houses, each with its own garden. Compared with the cramped conditions endured by later workers in the mill towns, the Barrow Bridge workers lived in some degree of luxury. The children of Robert Gardner's workers were provided with a splendid school and there was also a lecture hall and a village institute.

■ *Low Moor Mill, Clitheroe.* ■

In 1851 both Prince Albert and Benjamin Disraeli visited Barrow Bridge which was regarded as one of the wonders of the early Victorian Age. Later, General Booth, the founder of the Salvation Army, tried to buy the village and use it as a base from which to launch his 'war on poverty'. Alas the General failed to meet the asking price and the deal fell through.

The next stage in the architectural history of the Cotton Age was by far the most far-reaching. In the towns each businessman built his own mill along with streets to house his workers. All the mills had their own engines and chimneys which belched smoke. Gone were the water-powered mills set in villages and in came towns with mills bursting with sound

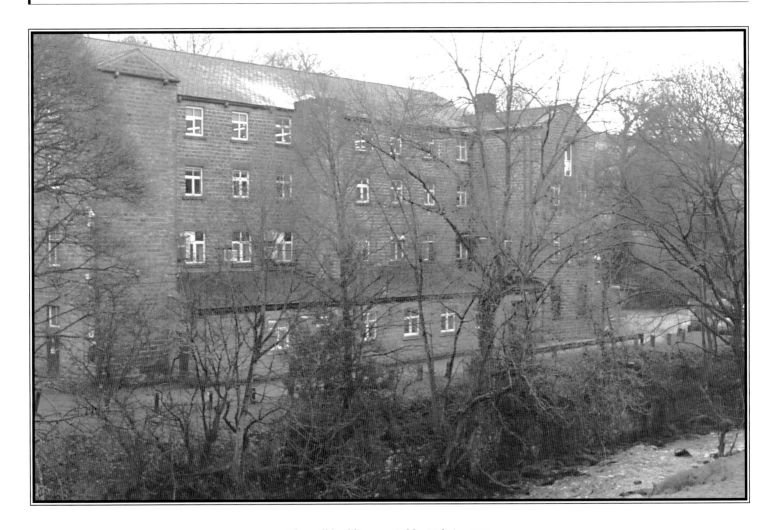

■ *The mill buildings at Calder Vale in 2011.* ■

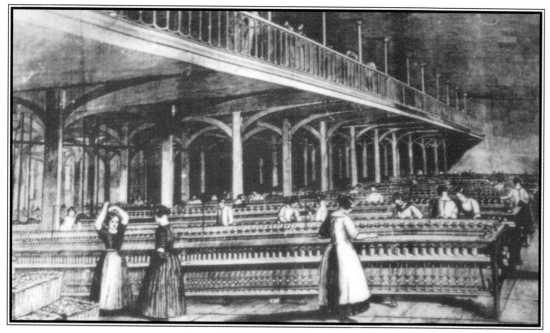

■ *An illustration showing workers at the Barrow Bridge complex in 1851 when Prince Albert paid a visit.* ■

do was to indicate whether he wished to have a spinning mill, a weaving mill or perhaps a combination of the two and then to stipulate how many machines he could afford and leave the rest to the architect.

The construction of a spinning mill is very different to that of a weaving factory; spinning mills were up to six storeys high whilst the buildings housing weaving looms were usually single-storied with lots of windows set at angles to allow the maximum light to reach each loom. The sheer weight of hundreds of vibrating looms also meant that a single-storey building with stone floors on which to bolt the machines was essential.

and hundreds of chimneys hurling soot into the atmosphere.

Mills were not just knocked together. Companies employed architects to construct the buildings and had contracts with suppliers who produced the machines within the factories. It was rather like our modern day when fitted kitchens can be made to order, except with a mill it was a much larger enterprise. The ambitious man of cotton looked at the designs available and ordered his mill. All he had to

Twiston, now just a tiny hamlet situated close to Pendle Hill was once a thriving settlement. In 1821 it had a water-powered mill and 236 residents. The owner was a Mr Taylor and the 1841 census records that there was one overlooker, 18 weavers, 4 winders, 2 spinners, 2 tearers, 2 rovers, 2 carding piercers, 2 carpet printers, 1 engine feeder, 1 cotton picker, 1

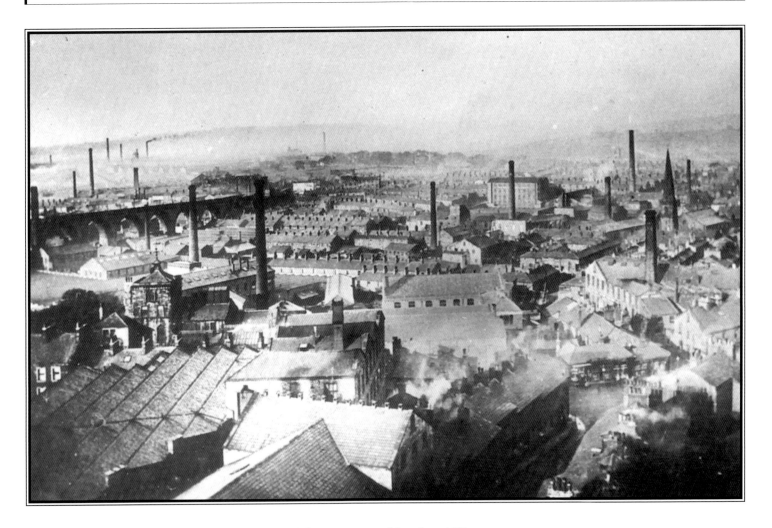

■ *The cotton town of Burnley, c1910.* ■

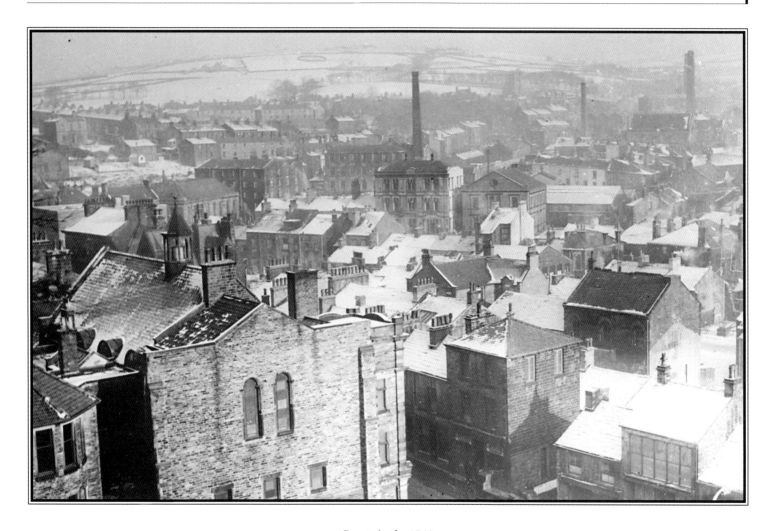

■ Bacup in the 1940s. ■

block printer, 1 blow feeder and 2 paupers. This suggests that this mill could carry out the whole process from raw cotton to the finished cloth.

In 1882 there was a disastrous fire at the mill and it was never rebuilt. However, the old mill pond still exists, much to the delight of today's naturalists.

As mills closed, far too many of these solid structures were demolished despite the fact that they could have been developed for use as flats or industrial units. Fortunately, though, several mills have been Grade II listed and among these is the Acorn Mill in Oldham now converted into flats; and the cotton works built for Sir John Holden in Bolton which overlooks the Eagley Brook Valley and is now up-market apartments with the original mill façade retained.

India Mill in Darwen which was built between 1859 and 1871 is also Grade II listed. It is now divided into industrial units and offices and still has its 303-ft chimney.

Stanley Mill in Burnley, another listed building, is now run by Sportex clothing and is described as '*A cotton weaving mill – 1891. Made of rock-faced sandstone blocks with some ashlar, a slate roof and glazed northern lights. There is a storied warehouse and engine room to the west and an office block at the front. There are two storeys over a basement and a cast-iron fire escape. There is a circular chimney and a stable block.*' (From British Listed Buildings Online.)

The typical view of any cotton town at the peak of the cotton industry was one of a forest of chimneys, and the smoke issuing from them meant another boiler and engine was working at full steam. Some of today's popular exhibits from the days of cotton are the mighty Lancashire steam engines. There are splendid

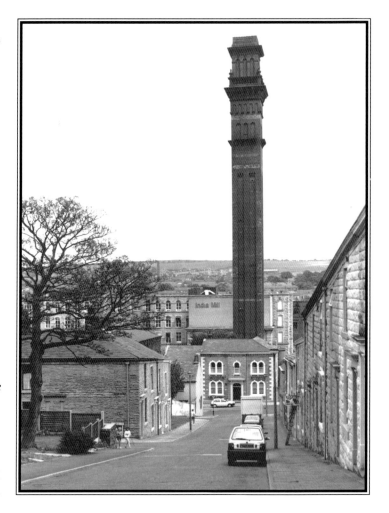

■ *India Mill, with its imposing chimney.* ■

■ *Stanley Mill still overlooks the streets which once housed the workers.* ■

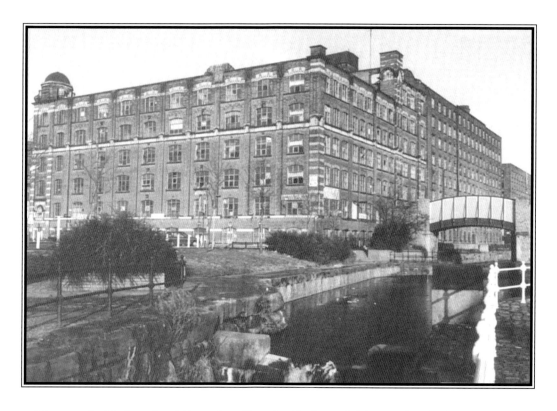

■ *These are the McConnel and Kennedy Mills set beside the Rochdale Canal and which include some of the earliest large textile factories ever built. Behind the canal bridge is the Sedgewick spinning mill which was constructed in 1820 and had eight storeys. During construction, fireproofing techniques were used. To the left of the picture is a domed tower. This dominates Royal Mill, built in 1912, which was powered by electricity from the day it opened and was the most advanced designed mill in the world at that time.* ■

working examples at Ellenroad in Milnrow near Rochdale; at Bancroft Mill in Barnoldswick; and at Queen Street Mill in Burnley. Steam engines provided the power for both weaving and spinning mills and each required a mighty power source. It was in the spinning mills that the biggest engines were required. All engines were kept as clean as a hospital ward and the man in charge was the master of his domain and even his bosses played second fiddle to his wishes.

Horizontal type engines were sufficient to power weaving mills and when these were ordered the owner specified how many looms he wanted to operate and the company built them to order. A visit around the town of Darwen is a history lesson in itself. Spread around the town is a wide selection of mill machinery and even when seen in the open air the huge size and the engineering skill involved can still be appreciated.

Places like Ellenroad Engine House at Milnrow where the engines are in enclosed spaces take the breath away. In Darwen there is a mill engine made in Bolton in 1905 and which was ordered to provide power for 1,224 looms.

In spinning mills a vertical steam engine was used and its enormous flywheel and associated driving ropes operated from a shaft operating on each of several floors. These drove spinning frames each with a length of 100 feet and driving spindles revolving at 10,000 revolutions per minute.

Every engineer treasured his engine and gave affectionate names to his machines. These were often, like ships, named after women but in the early days Victoria was a popular choice; engines built just after the First World War were called Peace.

It was not economic to keep an engine running during periods of meal breaks and so a donkey engine of a much lower power kept the system just ticking over. A really skilled engineer could synchronise the speeds so well that there was hardly any jolt when one machine took over from the other.

There were usually twin boilers and, until replaced by automatic hoppers, stokers were kept busy with huge shovels to keep the 'monster' fed. Lancashire boilers not only made good steam but also produced lots of smoke.

There were two worries faced by mill owners and workers alike. These were fires and boiler explosions. The latter were catastrophic and were due to the carelessness or laziness of mill engineers. Fires had to be stoked but also kept 'ticking over' during weekends. A build up of uncontrolled steam meant explosions of immense power. In the late 1940s, an engine explosion at a Rylands Street mill in Burnley caused the huge flywheel to go through the wall of the building. In a Blackburn mill the explosion was so violent that the whole system disintegrated and disappeared through a hole in the roof. While the engineers regretted the replacement of their beloved engines by electric power, there could be no doubt that mills became much safer. In later times each loom had its own power source and this meant that they could be stopped individually.

In 1906, as the cost of transporting yarn from Rochdale and Oldham to supply the raw material for the looms at Bacup was increasing, the idea of a new cotton spinning mill was mooted. In 1907, therefore, the Ross Spinning Company was founded and the new state-of-the-art mill was in full operation by 1912 and continued working until 1982. When it was finally demolished, bricks in excess of 1,500 tons were taken from the chimney.

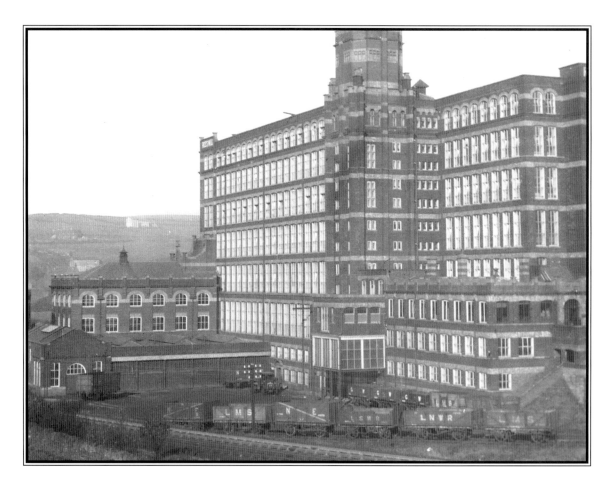

■ *The impressive Ross spinning mill seen here in 1920. In the foreground is the railway line leading into the heart of the mill.* ■

THE MILL OWNERS

E VEN IN ITS HEYDAY the cotton industry was very competitive and it took skill, bravery and determination by those involved to survive. Most cotton businesses were short-lived but there were a few families who not only made early fortunes but continued to dominate the industry.

Nowhere is this better illustrated than in the case of the Hargreaves family who began as weavers in the 15th century and whose descendent, James Hargreaves, invented the spinning jenny which heralded the Machine Age. The family was dominant in the Accrington area until the 1990s and their Moscow Mill complex has now evolved into the Oswaldtwistle Mills Shopping Outlet which attracts visitors from all over Britain. The man still very much in charge is Peter Hargreaves and he was instrumental in setting up what has become known as the Time Tunnel which traces the history of the cotton industry. Visitors to the mills should not miss this exhibit.

Another Accrington dynasty was the Highams. Their illustrious history with regard to the cotton industry dates back to the days of Eli Higham. Born at Ewood in Blackburn in 1833, Eli began his working life as a taper at the age of only seven! In 1858 he moved to Melbourne Mill in Accrington and was described as a taper or, better still, as a tape sizer. The skill required for this particular job, as with that of many of the mill workers, was more involved than is often realised.

The correct mixing of the size, which had a flour base, was important, as was the method of application of the correct amount of size to the warps. The temperature and the humidity of the working area also had to be carefully controlled. As a consequence, the sizing room was always a hot and humid place in which to work. Only one or, at the most, two sizers were employed in each mill. Eli was such a skilled operator that eventually he was able to set up his own company.

Eli Higham, a very religious man, become a pillar of society. For the whole of his working life he gave 10% of his profits to Oak Street Congregational Church in Accrington, an edifice which was sadly demolished in 1965. In June 1864 Eli's wife Mary died at the age of only 32, leaving him with four young children. By this time he was already established in business and was described as a 'cotton waste dealer and a manufacturer in sizing composition'. In 1861 Eli entered into partnership with James Jackson, also described as a cotton dealer, and moved to Cornholme on the outskirts of Todmorden. There seems to be no doubt that the loss of his wife resulted in Eli pouring all his energies into his work.

The new project was at Frieldhurst Mill, also called Law Mill, situated at Ing Bottom. In 1795 it was a cotton mill powered by water but soon reverted to its original function of grinding corn. By 1811, however, the mill was devoted to cotton spinning and operated 1,920 spindles. Later it was described as a 'power loom factory' before becoming a dye works. John Law was listed as the owner in 1837 and the

Varley Brothers in 1905 with Highams operating in the period in between. At one point it was converted to steam and the dam was later referred to as 'Varley's Pool'.

Eli Higham was becoming ever more prosperous despite the downturn caused by the American Civil War resulting in a cotton famine, though in 1866 he encountered problems problems with water pollution at Frieldhurst and responded to the River Pollution Commission as follows:

My works are situated on the Calder. Employ 50 hands. Rateable Value of works. The bed of the river has silted up. My works are not affected by floods. The condition of the river has not changed during the last three years within my knowledge. It is polluted by works above and not by mine. Obtain supply of water jointly from the river and from land drainage. Manufacture 280,000 pounds of goods to the value of £10,400. The whole of the waste liquid from my works flows direct into the stream. Use both steam and water as power; steam 10 horse power and water nominal 15 horse power. Consume yearly about 400 tons of coal, ashes from which are partly thrown into the river and partly to repair roads. The excrements of my work people are conveyed into the river. No suggestions to offer.

In July 1870 the report came back to haunt Eli Higham when a massive rain storm caused floods which not only damaged Frieldhurst Mill but also devastated the Highams' home at nearby Vale Manse. It was these events which persuaded Eli Higham to move both his works and his family

■ *Eli Higham in a photograph of 1860.* ■

back to the Accrington area. He took possession of a small works at Woodnook which became the power base from which the family's fortune was generated, and for the first time he felt able to spend money on himself and his family.

Woodnook proved to be an economic success and it was quickly developed into a mill area. From the 1870s other mills were established such as Victoria, Royal, Albert, Ellesmere and Lodge mills. Workers poured in to work for the Highams and Eli built a splendid home for his family and the Accrington Vale Manse even had its own open-air swimming pool. The street close to the Manse is still known as Bath Street.

Eli never forgot the dangers of flooding which had caused him so many problems at Cornholme and he spent money on building flood defences around his Accrington mills. By 1888 Eli also owned a huge textile complex at Castleton Lower Mills near Rochdale.

Apart from floods, a much more worrying aspect of the cotton industry was the ever present threat of fire and this affected Woodnook in 1885. The cause was obvious – a lap carrier walked into a gas flame and his pack ignited very quickly. At this time 'bat winged' gas burners lit the whole factory and two floors of machinery were totally destroyed. Eli Higham junior was the manager and he skilfully supervised repairs and also, more significantly, the installation of new machinery. This involved siting a huge mule in an attic space and below there was sufficient room to house a few looms and on the ground floor there were ten breaker carding engines, one roving frame, three finishers and a machine called a Derby Doubler.

Until 1885 the mill was powered by a combination of a waterwheel and a small steam engine but following the fire it was decided that steam was to be the only source of power. The site increased rapidly in size and became ever more congested as the weaving shed now contained 100 looms. A further extension increased the number of the looms in 1911 at which time the cost of coal was a factor for the Highams. They joined forces with the Woodnook Mining Company which owned land between the railway and the watercourse. The brook was culverted and over this a huge weaving shed was built. Each loom was then linked to its own electric point which obviously reduced the risk of fire. All these developments cost money and the Highams went into partnership with John Warburton Limited.

This was a time when the Lancashire cotton industry was at its peak. Fortunes depended upon small profit margins but huge volumes of textiles. The men of cotton had to buy raw cotton as cheaply as possible and sell their finished goods at the highest prices possible at the time. This involved the setting up of two cotton exchanges, one in Liverpool and the other in Manchester. The ambitious mill owners made full use of the expanding railway network and made regular visits to the exchanges which were very opulent buildings with architecture to rival any of the stately Victorian buildings found all over Lancashire.

The decline of the cotton industry began in the 1920s, endured bleak times in the 1930s and revived a little during the 1960s before another decline led to a final fall in the fortunes of Lancashire cotton. The Highams at Woodnook survived longer than most and amalgamated with the Hilden Group which was owned by the Hargreaves family. Here

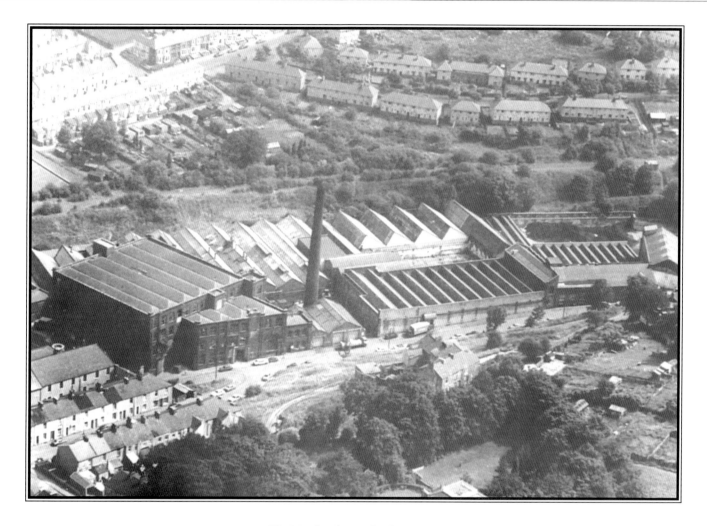

■ *The Woodnook complex in 1980.* ■

then were two of Accrington's most historic cotton families joined together. In 1985 Alan Smith who formerly managed the Premier Mill at Great Harwood was hard at work saving looms from the scrap yard and using them to weave cloth for an export order to Denmark. Hilden survived until its final closure in the early years of the 21st century but thankfully the Hargreaves cotton connection is still to be seen at Oswaldtwistle Mills and its Time Tunnel.

Whilst the Hargreaves and the Higham dynasties dominated Accrington, there were other towns which had their own 'Princes of Cotton'. One of the most successful of these was the Horrocks empire which dominated the cotton industry in Preston.

John Horrocks (1768–1804) was born in the village of Edgworth, near Bolton. It is hard to realise the part played by such small settlements in the early days of the cotton industry but the village once had a huge mill which operated until well into the 20th century. Edgworth lies within the valley of the little River Brock. Apart from its origins as a 19th-century spinning mill village, there are also remnants of bleachworks and cottages associated with both industries. Entwistle reservoir was constructed in 1838 and extended to provide more water for the bleachworks in 1840.

How did John Horrocks of Edgworth develop the world-famous firm which so dominated Preston for more than 150 years? His father owned a small quarry and the lad's first job involved dressing and polishing millstones. He did, however, take a great interest in the developing cotton industry and saw an opportunity to play a part in this and hopefully to make his fortune. He persuaded his father to buy a few spinning machines and set them up in the corner of an office. He usually worked these frames himself and travelled by horseback all over Lancashire selling his yarn. This was soon recognised as being of the highest quality and orders began to pour in.

In 1791 he moved to Preston and began to produce high-quality cotton shirtings, woven from his own yarn. He embraced all the new machinery but always refused to compromise on quality. His efforts soon attracted wealthy and equally ambitious bankers who encouraged young Horrocks to build more and ever larger mills. The quality of his goods was noticed by the East India Company who gave him a monopoly to produce textiles for the Indian market. In 1801 John realised that he could not run his expanding business on his own and first took his older brother and then Messrs Miller and Whitehead into partnership. The firm of Horrocks, Miller and Company went from strength to strength. John Horrocks can only be described as a 'workaholic' and in 1802 he was sufficiently affluent to be elected as an MP for Preston.

It seems that his self-imposed workload was too much, even for a relatively young man and, in 1804, John Horrocks died at the tender age of 36. The cause of his death was listed as 'brain fever' – this could well mean a heart attack and probably a stroke. Horrocks had been among the first to realise that to make the most profit, a company needed to realise the potential of both spinning and weaving. Almost a century after his death, the firm founded by John Horrocks was at the forefront of cotton mill design. In 1895 it was constructing new mills incorporating the latest designs. This involved the installation of widely-spaced posts and

beams made of rolled steel and floors of concrete rather than wood. There were solid walls of Accrington brick and very large windows which cut down on hefty lighting bills. The company built the huge Tulketh Mill which had a solid tower housing an enormous water tank linked to a sprinkler system to reduce any damage caused by fire. At this time there was a huge demand for good-quality bricks which was one of the spin-off industries from the cotton boom.

Another family who cannot be ignored were the Peels who were not spinners or weavers but were concerned with bleaching and printing.

The Peel family have been described as the Arkwrights of the textile printing world and this is very close to the truth. Like most of the real pioneers of cotton, they rose from very simple beginnings to become a dominant force.

In the mid 18th century the Peels were yeomen farmers living at Hole House Farm near Blackburn and their dwelling was on Fish Lane. The founder of what became a printing empire was Robert Peel and he had a large family to feed. Farm work and handloom weaving of wool and, later, cotton was hard work. He had noticed, however, that some people were making money by producing what were known as Blackburn Greys which had a linen weft and a cotton warp. Robert decided to diversify and produce his own brand of Blackburn Greys and the sheer quality of his product was soon appreciated. His problem, along with that of many others, was a shortage of spinning yarn and this accounts for Peel's early association with James Hargreaves whose spinning jenny began to solve this problem.

Robert Peel was not only a hard worker but was much

■ *John Horrocks* ■

quicker than any of his rivals to realise the importance of new machinery. He developed a home-based spinning 'factory' and found enough space to adopt a recently invented carding cylinder. He also became interested in the printing of calico which was then very much in its infancy. He carried out a series of ground-breaking experiments to discover if it was possible to print on fabric by means of machinery. Initially his efforts were within his home environment with his wife and daughters ironing the fabric prior to hand-printing on it.

Then came a lucky break. The family had become affluent enough to eat their meals on pewter plates, with the main base for the manufacture of this alloy being based in Wigan. Robert Peel scratched a pattern on the base of a plate and wondered if this could be incorporated onto a roller. His first image was of a parsley leaf and from that time onwards Robert became known as Parsley Peel.

The next step was to make a wooden cylinder with an engraved strip of copper incorporated into it. Peel and Company at first based at Church near Accrington and Oswaldtwistle was set for a very bright and prosperous future. 'Parsley' soon gave up farming and his sons, equally talented and ambitious, worked hard, made their fortunes and eventually employed large numbers of people.

When Robert Peel Junior was only twenty years old, he began 'serious' cotton printing and obtained the much needed finance by joining in a partnership with his uncle, James Haworth, and William Yates of Blackburn. The Peels realised that they had to expand and they purchased a ruined corn mill on the outskirts of what was then the insignificant small town of Bury. The area was known as the Ground and

was developed into firstly a cotton print works and, later, a spinning mill was added. All the partners initially lived in frugal style and put all their money into expanding the business. Robert Peel sealed his partnership with William Yates by marrying his 17-year-old daughter, Ellen.

The high quality of the Peel products led eventually to large profits and their son Robert was eventually knighted and became Prime Minister of Great Britain. It was Robert, educated at Harrow and Christ Church, Oxford, who established the first organised police force which became known as Peelers and later as 'Bobbies'.

Other members of the Peel family were also hardworking and set up print works in places such as Burnley, Altham, Foxhill Bank near the former family home at Oswaldtwistle, and also on the banks of the River Ribble at the now idyllic village of Sawley. The Peels were always at the forefront of new inventions and innovations, one of which was called the 'resist'. This involved the spreading of a paste in the areas of a pattern which was to remain white whilst the rest of the dye was printing. The paste did indeed resist the process of colouring.

Apart from the mighty Peels there were other capable men working on the chemistry of dyes. One such was John Mercer (1791–1866). He was born at Dean Farm in Great Harwood and, at the tender age of nine, was employed as a bobbin winder in a cotton mill. He was very intelligent and by 1807 he was employed as a weaver and a chemist in a calico print works at Oakenshaw. He was made a partner in the firm in 1825 and was well-known as an inventor of dyes. He is also said to have been the inventor of the first commercially produced red ink. His greatest claim to fame was his

development mercerization. This involved treating the cotton fibres with caustic soda to produce a really silky texture. Mercer patented this in 1850 but owing to the then high cost of caustic soda the process was not a commercial success until the 1890s, well after the inventor's death.

John Mercer's family celebrated his work by funding a clock overlooking the town hall in Great Harwood and a town park at nearby Clayton-le-Moors.

■ *John Mercer* ■

SUPPLIES, WAREHOUSES AND TRANSPORT

THE HEY-DAY OF Lancashire's cotton industry began in the plantations of the southern states of America where they used paddle steamers to transport the cotton along rivers, in particular the Mississippi, to sea ports such as New Orleans where it was then shipped across the Atlantic to Liverpool.

The raw bales were unloaded to warehouses at the docks where the bales were inspected, sorted and sold at the Cotton Exchange. Plainly, however, there would be no point in producing anything unless it could be sold at a profit and producers and merchants could not do any business unless they had regular contact with each other. This was the function of the Manchester Cotton Exchange, which first opened its doors in 1728. Not surprisingly the building stood on Exchange Street.

■ *Two 'Manchester men' on the steps of the Exchange in 1938. The 'TO LET' sign on the door indicates that all was not then well in the Cotton County.* ■

69

From the 1850s onwards, cotton mill owners were able to travel by train from all over Lancashire to the Manchester Cotton Exchange and were known as the 'Manchester men'. Each mill owner was allocated a reference number at the Exchange, e.g. E15, which marked the company's position within the building. The letter indicated the row in the Exchange and every pillar was numbered. All you had to do was stand by your space and wait for potential customers to approach you.

The Exchange was a hive of activity and here spinners, weavers, bleachers, dyers, printers, machine makers and merchants all had their allotted space and their customers knew precisely where they were to be found. Modern-day visitors can still get something of a feeling of the importance of the Exchange by visiting the Royal Exchange Theatre which is housed in the old Exchange building. On the day of the Exchange's closure the display board was left in situ so that the prices of the day can still be seen in all their impressive detail.

Many of the cotton warehouses in Manchester have recently been converted into upmarket hotels. One of these, the Britannia Hotel, was built by the textile firm of S. and J. Watts. It was founded by James Watts, a Mancunian industrialist whose textile business originated in a small weaver's cottage in Didsbury. He was one of the many ambitious and very able men who developed Manchester into 'Cottonopolis'. Watts made his money very quickly and was rich enough to become socially acceptable to both churchmen and the aristocracy. He entertained his guests at Abney Hall in Cheadle and, in 1857, Prince Albert visited him when he attended an Arts Treasures Exhibition.

James Watts clearly did not consider expense when he developed his home and he also ensured that his Manchester warehouse was equally impressive. He employed the best local architects Travis and Magnall and between 1851 and 1856 the warehouse came to resemble more of a stately home than a warehouse. It cost approximately £100,000, was made of best-quality sandstone and consisted of five storeys. The design resembled a Venetian palazzo and each storey was decorated in a different style, including Italian, English Elizabethan, French and Flemish. The finishing decorations could be appreciated as there were huge Gothic wheel style windows which flooded light into the interior and allowed the goods on sale to be shown to their best advantage.

With all this effort, expertise and financial outlay, it is no wonder that the Watts business was a dominant force for more than a century. There was almost a disaster in the Blitz of the early 1940s when the warehouse was hit by German bombs. The building was saved from total destruction when the fire was smothered by the heavy rolls of textiles.

Like the rest of the cotton industry, however, from the 1960s onwards, world markets with lower production and labour costs outstripped the British enterprises and, in 1972, even the Watts Empire fell victim and its once wonderful warehouse was destined for demolition. Salvation came in the 1980s when it was converted into the Britannia Hotel and the owners had the good sense to retain many of the building's original features.

Warehouse design evolved to meet the demands of the increasing trade and the changing requirements of the textile

industry. As with James Watts, some of the largest fortunes in the industry were not made by mill owners but by the merchants. They built their warehouses to flatter their customers, display the goods for sale and the designs reflect this. The warehouses had impressive frontages, and the rear of the buildings often consisted of cobbled yards where customers could arrive on horseback to find stabling. The walls were faced with white tiles which reflected light and customers were encouraged to go out into rear yards to fully appreciate the colours of the goods.

Many of these old warehouses exist today, especially in the area between Mosley Street and Whitworth Street; some, like the Britannia, are hotels, whilst others have become impressive office blocks, with many of their original features maintained. Architects have recognised four basic types of warehouse: firstly there were the Sale warehouses, with the Watts edifice as the prime example; secondly there were what have been defined as the Overseas Trade warehouses – these aimed to attract businessmen engaged in exporting usually cheap textiles to many places but particularly to the expanding British Empire. These buildings were less ostentatious and were best described as

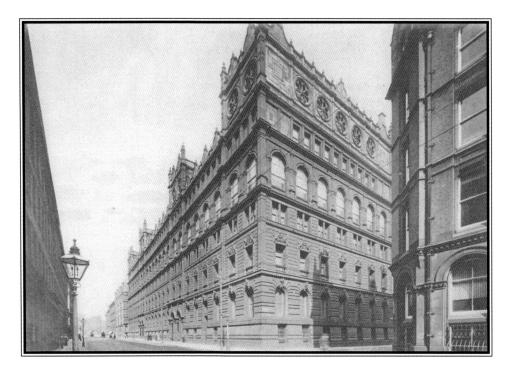

■ *The imposing Watts' warehouse in Manchester, c 1900. In the 21st century, it houses the Britannia Hotel.* ■

functional although the boardrooms were lavishly decorated so that their customers could be regally entertained. Thirdly, there were Packing warehouses, of which there are some fine examples on Whitworth Street. From 1880 onwards these warehouses developed quickly. Inside there were only comparatively small display areas but no expense was spared

on these and they were the height of luxury. Huge orders often resulted and space was needed for storing, packaging and labelling the goods ready for both local and overseas markets.

Finally, there were the Railway warehouses which became important after 1850 when the advantages of the fast movements of goods became apparent. The first of these railway warehouses to be built was at the terminus of the Liverpool and Manchester Railway which was directly opposite the world's first passenger station. This station has been restored and is now part of a museum complex. It is well worth an extended visit. Later examples were situated around London Road station which is now known as Manchester's main station, Piccadilly. The last major warehouse to be purpose-built was completed in Deansgate for the Northern Railway Company in the mid 1890s.

These warehouses would seem to suggest that the fortunes of cotton went from strength to strength in a continuous progression but this was far from the truth. To use a modern term, there were periods of boom and bust. One of the most traumatic of the busts is now known as the Cotton Famine.

The American Civil War (1861–1865) was fought largely over the issue of slavery. The fighting was between the states of the Unionist north and the eleven states of the Confederate south whose aim was to become independent from the north and to retain the slave labour which dominated the cotton fields.

As the war developed, the export of raw cotton into Liverpool virtually dried up. Liverpool traders had two reasons for suspending trade with the southern states of America.

Firstly they knew that the supply was bound to be limited but they also had warehouses already full of cotton which they intended to sit on and greedily wait for prices to rise!

This 'Cotton Famine' resulted in great hardship in Lancashire in the early 1860s. The people working in the Lancashire mills tended to support the Southern States and some ship owners decided to try to avoid the blockade imposed by the Northern States and bring in cotton from Liverpool. Not all of Britain felt like this and many supported the total abolition of slavery which had become the law in Britain in 1833. Two of the politicians who supported this view were John Bright and Richard Cobden and there are still streets in the cotton towns which proudly bear their names. There is no doubt, however, that the cotton famine did cause great hardship and philanthropists, many of whom were cotton men, set up food kitchens and handed out clothes to the needy. Many buildings and town parks were constructed to provide labour for the temporarily unemployed.

There was also a great incentive to open up markets for cotton in places such as the West Indies and India, and experiments were tried in Australia but in the latter case these were not successful.

'Busts' in cotton production were also caused by the two world wars. Many mills lay idle, though some were adapted to produce armaments. There was another major 'bust' in the 1930s when the Wall Street crash affected the whole of Europe. From the 1960s onwards there was not so much a bust as a steady decline in the cotton industry as foreign competition gained a stronghold.

THE MILL WORKERS

■

WHILST THE MILL OWNERS WORKED hard in order to construct new mills, install new machinery and calculate profits, their workers also had to work hard to keep body and soul together. Apart from earning their wages, the artisans also had to keep house and they had a well-organised daily routine.

The working week lasted from Monday to Saturday lunchtime and the day began with a visit from the knocker-up. In the days before alarm clocks, this was often the way for a retired worker to earn a few pennies from each householder. Each knocker-up had a long pole with a wire at the end and he scraped this against the bedroom window. He then waited until the occupant poked a head out of the window and called a sleepy thanks. Work was often hard to find and those who were late for work were soon sacked.

In the dark days of winter, candles were lit and workers dressed in a hurry and set off for their daily grind, with the sound of their clogs echoing along the cobbled streets.

The idea of cotton slums has been somewhat overstated because people looked after their own environment as well as they could. They kept their outdoor privies clean and these were white- or lime-washed. They also had ash pits at the rear and these were emptied by men with shovels and horse and carts; these workers were called scavengers. As soon as the

■ *A knocker-up at work. As a result of his activities, many houses had scratches on their bedroom windows.* ■

scavengers had departed, the women who were not working in the mills emerged with buckets of water and strong 'yard brushes' to give the area a 'reet good swilling'.

Monday was always wash day and was a ritual timed to follow a Sunday and before the smoking chimneys were pouring out their plume of filth. At this time the town of Rochdale was said to be 'smoking for England'. The wash day utensils were a far cry from our modern press-button society with sophisticated plumbing. Many people can still remember the dolly tub, the posser, the scrubbing board and the mangle which are now part of our history and relegated to exhibits in craft museums. Woe betide any coalman who had the nerve to deliver on a Monday morning!

There were also other scrubbing jobs to be done, including windowsills and doorsteps. A rubbing stone which was often coloured and another called a donkey stone was used to clean and spruce up doorsteps. Before this the windows were given a clean, with the upstairs being rubbed by a rag attached to a clothes prop or, if the housewife could, she leaned out of the open window to reach the glass.

A typical terraced house prior to 1914 was, to say the least, basic but it was solidly built of stone and brick, and probably

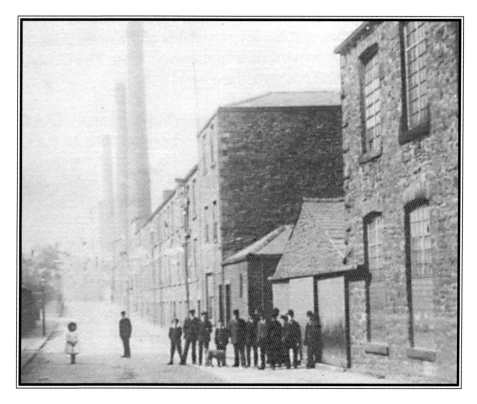

■ *This 1910 shot of an Accrington street shows the proximity of the houses to the mills. No wonder the workers were forever scrubbing their homes to keep them clean.* ■

an improvement on some of the old decaying cottages typical of 18th- and 19th-century England. The accommodation comprised a living kitchen and within this was a side area which had a slop stone and, later, there was probably a cold

water tap. Beneath this there was a space in which could be placed a bucket or a large jug. Hot water was obtained by placing large pans on the fire but some households had a copper boiler with a fire beneath. Some of the living room fires had a side oven or even a boiler and cooking was always done on the fire.

The floors of these early houses were flagged, which could make them quite cold, and a bit colourless. Families often spent their too-few leisure hours in making pegged mats which is a craft still employed by a few people today. This involved cutting up old clothes into strips. Pegs were used to push these strips into cheap sacking. There was a tradition of making a pegged rug as a run-up to Christmas. The old mat was placed in front of the slop stone and the new covering revealed in all of its glory on Christmas morning.

Most houses had what was known as black lead nights. This was the time when all the iron work was polished until it was shiny and black, as were the copper utensils, including the kettle.

Bedrooms were spartan, to say the least. Initially there was no covering on the floor but as the workers gradually became more affluent, some put oilcloth down. The Storey family of Lancaster made a fortune from the production of this commodity. Old rug mats were also placed on the floor so that cold feet would not be further assaulted by contact with cold floors.

With their working week finishing on Saturday morning, many workers spent the weekends at their allotments and also tended them after work during the summer. Many kept hens and rabbits there, as well as growing their own fruit and vegetables. It was also a place where they could get together with their friends and family for a good 'natter'.

At the mills, there was a practice of fining the workforce for being late or taking time off without permission and charging workers for hot water for their drinks.

A copy of mill rules issued by a Haslingden firm in 1851 states:

1) Any person leaving his work and found talking with any of the other workpeople shall be fined two pence for each offence.

2) All persons in our employ shall serve four weeks' notice before leaving their employ; but the proprietors shall and will turn any person off without notice being given.

3) The masters would recommend that all their workpeople wash themselves every morning, but they shall wash themselves at least twice every week – Monday morning and Thursday morning – and any found not washed will be fined three pence for each offence.

Even in 1877, the manufacturers had complete control when the weavers' organisations were requested to attend a meeting with the employers to consider a proposal to reduce wages by 10%. Needless to say, the weavers decided to accept the 10% reduction.

In 1959 the cotton industry, with government agreement, was reorganised and 50% of the spindles were taken out of use and 37% of the looms went the same way. The government paid compensation to mill owners to make sure that this happened. It is no wonder that young people were reluctant to commit their future to textiles and preferred to look for employment in other industries.

WORKERS' PLAYTIME

—■—

BEFORE THE INDUSTRIAL REVOLUTION and the reign of King Cotton, the majority of people lived in the countryside and were ruled over by an aristocracy in what was a feudal system. Leisure was the privilege of the so-called ruling classes, and this applied to sport which was once largely a power base for those from the public schools and the old universities. The concept of having a holiday was far in the future and most people had not travelled beyond their own village. All this gradually changed with the advent of the Industrial Age.

There was a vast increase in population and even the harshest of masters realised that their workers really did need a playtime. Most mills had their own football, cricket and netball teams and there was great competition between the teams. Their best players were often slipped a 'backhander' to encourage them to play. Here then, were the first seeds of professional sport. It is no accident that most of the twelve teams which made up the Football League founded in 1888 were from the cotton towns such as Preston, Bolton, Blackburn, Accrington and Burnley, whilst Everton was close to the port of Liverpool. Other original members were teams from the Midlands, around Birmingham and Nottingham, which were also in the heartlands of the Industrial Revolution.

The first two professional cricket leagues were the Central

Lancashire and the Lancashire League. Both the game of football and cricket attracted large crowds of spectators who were willing to pay hard cash to see their teams win. Looking at old photographs of the crowds, three things are immediately obvious: the almost total absence of women, the number of people smoking whilst watching the game and the number of hand-held rattles which sounded like an alarm call and, when swung around, needed skilled operators to prevent damage to those nearby.

Other sports popular in cotton country were darts, whose boards were initially made from logs of wood, originally called 'log end darts', and bowls. Many pubs and all town parks had greens and bowling clubs; and with tennis being another favourite sport, soon bowling and tennis clubs were established. Gradually women, too, were allowed to participate in both bowls and tennis.

As well as sport, the theatre and religion played major roles in the lives of the cotton workers. The religious houses of all sects were the focus of community developments which extended the services into Sunday schools and entertainment. There were also concert parties, light opera and even grand opera groups, as well as singing and dancing competitions.

Again, many people preferred not to perform but to watch and be entertained. The amateur entertainments attracted paying customers and this explains why first the music halls and then the cinema became so popular. All towns had theatres and cinemas which were often referred to as 'flea pits' even though they had impressive sounding names such as Palladium, Odeon, Roxy, Regal, and Coliseum.

The idea of having a holiday with entertainment laid on,

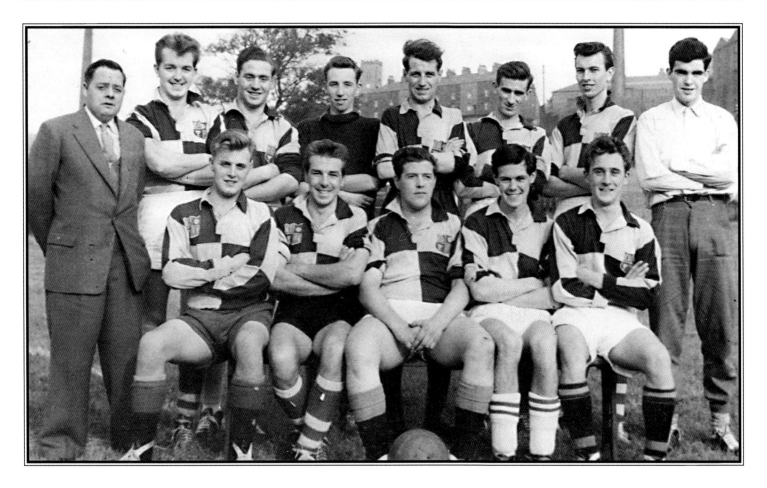

■ *Moscow Mill's football team were called the Enfield Dynamoes. Seen here in 1955 the team included a couple of guest players: (top, l. to r. – Harry Lee (in civvies), Ken Wilcock, Michael Duxbury, Peter Jordan, guest, Bill Harvey, Ken Street, Michael Gallagher (in civvies); (bottom, l. to r. – Peter Hargreaves (the owner's son), guest, Jimmy Kenyon, guest, Brian Smilk.* ■

■ *A 1950s' view of Burnley's Turf Moor football ground – count the cloth caps!* ■

■ Church Cricket Club v Accrington, 1905. ■

though, was slow to develop and the Lancashire Wakes Weeks have fascinating but very different origins. For many years the death of a prominent man, be it a lord of the manor or a business magnate, meant a massive funeral called a wake. A day's holiday for the workers was part of the legacy as the dearly departed was remembered. Later, the mill workers were allowed first a week's holiday and then a fortnight, initially without pay. Most voluntarily set aside a portion of their yearly wages to put it into a holiday fund. One person ran the fund and although most who did so were honest, there were a

■ *Towneley Bowling Club, 1950.* ■

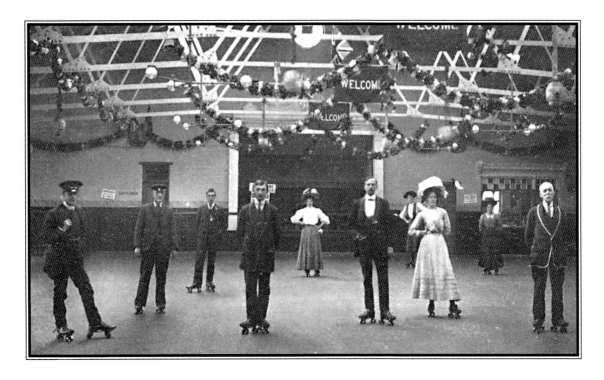

Even roller skating was popular. The Premier Skating Rink at Stacksteads near Bacup, Christmas 1890. ▪

few who did 'a runner with the brass'. With typical Lancashire humour, these holiday funds became known as the 'Diddle 'em clubs'.

The demand for holidays led to the growth of what have become known as the Wakes Resorts. The main ones were New Brighton, Southport, Lytham St Anne's, Blackpool, Fleetwood and Morecambe. Each family not only had its own

favourite resort but also its own chosen place to stay. When they left their lodging house to board the steam train special taking them home, they had already booked for next year.

Even the local cotton town newspapers catered for the wakes holidays by ensuring that there were copies on sale at known locations at the various resorts.

There were many links between the cotton towns and the

■ *Enjoying Wakes Week at Blackpool in 1955.* ■

■ *Folk in Burnley setting off on their holidays, c1930s.* ■

■ *Enjoying a Punch and Judy show on Morecambe beach in 1920.* ■

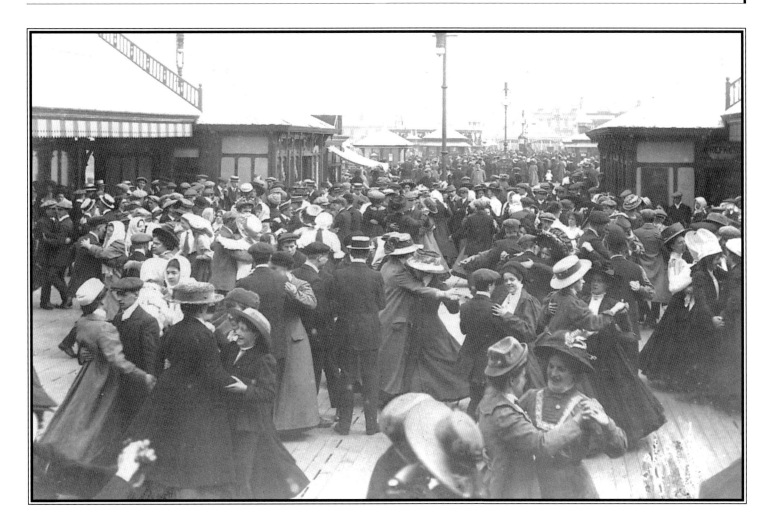

■ *Dancing on Blackpool pier in 1905.* ■

wakes resorts including the crowning of the Cotton Queens. Each town held contests to find the prettiest mill girl and the winner was taken to Blackpool where she in turn took part in a grand competition for the honour of being crowned the overall Cotton Queen of Lancashire.

Sporting competitions were also held and venues for sports such as bowls were focused around the Fylde coast. The most popular of these was based at the Waterloo Hotel in Blackpool which still has a fine crown green; there also excellent greens around Southport, St Anne's and Fleetwood.

People gathered at railway and bus stations to board the Wakes Specials and those who could not afford to go away often scraped enough money together to go on day trips. These were not just to the wakes resorts but to other locations, including the Yorkshire Dales, the Lake District and North Wales. There were also mystery trips where passengers took a risk and booked without knowing the precise destination of where they were going. The railway companies also advertised 'run about tickets' which lasted a week and allowed passengers to travel to any location mentioned in the itinerary. Out of the wakes season, outings were organised by rail or by coach to see the illuminations at Morecambe and Blackpool, and to the Belle View Brass Band contests.

A reminder of the seaside was brought to many towns when the fair arrived and set up business on land in or close to the parks. Those who could not afford to go away could enjoy the roundabouts, dodgem cars and swing boats whilst feasting on ice cream, candy floss, doughnuts and small roasted potatoes called chats. One of the largest of these fairs took place in Burnley where the wakes holiday was called

Burnley Fair. It lasted almost a fortnight with the second week being known as the Pot Fair. Many people used this as a chance to buy cheap cooking utensils but they also had to take care when inspecting the goods, especially on the last day when the stalls were shutting up and their owners moving on. The Burnley Fair still operates to this day.

Many of the larger mill complexes rewarded their workers by organising free day trips usually to the seaside. There people could stroll along the promenades and onto the piers where they could dance to the orchestras playing. At Blackpool, sea foods including oysters were on offer, whilst at Yates Wine Lodge champagne was available on tap! Many enjoyed a whole day of dancing in the famous Tower Ballroom.

From the 1860s onwards most towns set up their own Natural History Societies and contributed to the information which is still being gathered relating to the wildlife of the area. There was a heavy concentration upon the wildlife within walking distance of the mills but members also made full use of the railway network. In Prestwich near Manchester, for example, there is a pub called the Railway and Naturalist and this was a meeting point for members to compare notes and compile lists and travel diaries. Many cotton artisans became skilled botanists and zoologists. Some joined study groups organised by the Workers Educational Association (WEA) which provided lecturers usually appointed by the nearest university. These offered facilities to study all branches of the arts and sciences. For many, this was the first rung onto the academic ladder. Many institutions such as the Mechanics' Institute were also set up where workers could study part-time.

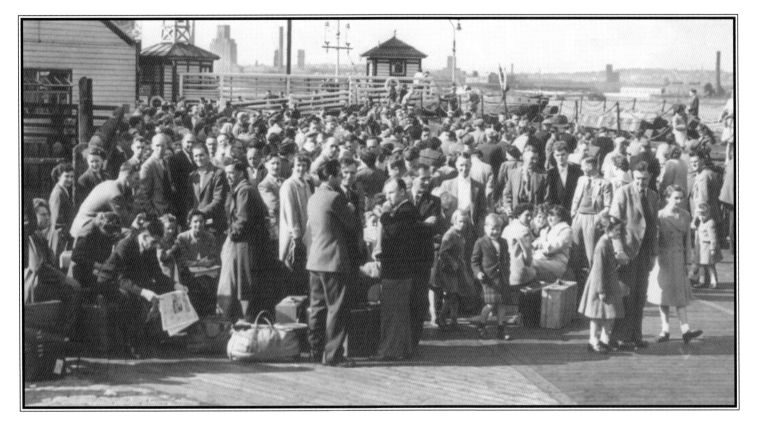

■ *Holidaymakers setting off from Liverpool for a day trip to the Isle of Man in the 1950s.* ■

These educational opportunities were almost exclusively the province of men as were the Working Men's Clubs where men could play cards, billiards and snooker or darts, whilst enjoying a drink at competitive prices. Women, especially in summer, met with friends and neighbours whilst drinking tea on their doorsteps and these gatherings were known as 'campings'. The ladies would take it in turns to brew up.

The few times when whole families gathered together

■ *The Mechanics Hall at St James's Street in Bacup was built in 1846 to teach the basic principles of mechanics and chemistry. The building to the right of this 1950s picture was the old corn mill.* ■

provided flowers for the park and some parks had boating lakes, whilst others boasted open-air swimming pools.

Several towns also had municipal baths. These provided not only the chance to swim and take part in swimming galas but also to enjoy a hot bath, known as a slipper bath, rather than having one at home in a tin bath in front of the fire.

Owning a piano, if you could afford it, was one way of enjoying leisure time without leaving home. Regular visits were made to music shops to purchase sheet music, and families gathered around the piano to listen and sing along to the latest tunes. Although they were expensive, there were also wind-up gramophones and battery-powered wirelesses available.

were usually for a stroll and perhaps a picnic in the park. On Sunday afternoons they would sit on seats around the bandstands and be entertained by one of the many brass or silver bands, such as those of the Salvation Army. Many of Lancashire's parks were funded by the profits from cotton magnates and others by local corporations. Greenhouses

As more and more money became available and, even more importantly, more free time, people began to take up

■ *The Burnley Mechanics Institute seen here in 1980.* ■

hobbies such as collecting stamps, cigarette packets and cards, matchboxes, football programmes, photographs of film stars and theatre programmes.

This hobby of collecting memorabilia continues to this day and over the last twelve years, I have started my own hobby of collecting photographs relating to the early days of the cotton industry. This, in turn, has led me to visit many museums and other sites in Lancashire which aim to preserve the story of Lancashire's cotton.

PLACES TO VISIT

HOWEVER MUCH YOU READ ABOUT and look at images relating to the history of Lancashire's cotton industry, there is nothing to beat standing next to one of the surviving mills to appreciate both the scale and the architectural skills involved in its construction. It is impossible to appreciate the evolution of the machines which powered the Industrial Age unless you see them for yourself.

No chance should be missed to visit the museums devoted to this part of Lancashire's heritage. Many of them have volunteer staff who worked in the industry. Do not be shy about asking questions because the people there are happy to talk and pass on their memories and explain the jobs they did. All of them will say that the work was hard, the wages often low but they were glad to have a job and took pride in the fact that they did this properly.

As mentioned in Chapter 3, one place which covers the whole history of cotton is the Helmshore Mills Museum (tel. 01706 226459) which, in recent years, has had a really impressive face lift. The site is mainly composed of two mill buildings and associated ponds or lodges, with the River Ogden, a tributary of the Irwell, running in a north-south direction through it.

The commercial history of the two mills has been very different. The older mill was built in 1789 as a woollen fulling mill and funded by six members of the Turner family. Three were in the cotton trade in Blackburn and the other three in the wool trade at Martholme. The cotton brothers soon lost interest and the enterprise continued as a woollen mill. It was the son of one of the founding fathers (William Turner 1793–1852) who built a much larger mill in the same area. This became functional round about 1820 and was for carding, spinning and weaving wool; the resulting cloth would have been finished in the fulling mill.

A fire in 1857 destroyed most of this second mill and it was rebuilt in 1860. Following William Turner's death in 1852 the later mill (referred to today as Whitaker's Mill (spelt with one 't') entered a strange phase where it alternated between working wool and cotton. In the 1920s cotton became dominant and this was the case until the mill closed down over Christmas 1978. At this time some of the original machines were still operating and can be seen in the museum today.

The fulling mill which today is called the Higher Mill was being operated as a wool mill from 1875 by Lawrence Whittaker (with two 't's). His descendants ran the fulling mill until its closure in June 1967. It would seem that the two families were related and somewhere along the line, a 't' was either lost or gained. In the mill the fulling stocks and waterwheels can still be seen and can still be operated. The Helmshore complex houses the machinery of the Platt Company. There is also a complete range of Arkwright preparatory machinery, together with the water frame.

The Helmshore complex should be viewed as a joint visit with its sister museum, the Queen Street Mill at Harle Syke

between Burnley and Nelson (tel. 01282 412555). This is a steam-driven weaving mill with large numbers of Lancashire looms and, on a working day, a real impression of what a weaver's working life was like can soon be appreciated.

Not too far away from Helmshore is the Hall i' th' Wood museum on the outskirts of Bolton (tel. 01204 332370). It is open all through the summer months and at other times by appointment. The half-timbered building is Grade II listed and its survival is due to the generosity of William Hesketh Lever who was born in Bolton in 1851 and made his fortune from soap based around his Port Sunlight works on the Wirral coast of the River Mersey. William became Lord Leverhulme but never forgot his Bolton roots. In 1899 he paid for the restoration of the Hall which is now a museum devoted to the life of Samuel Crompton, described in Chapter 2.

One excellent establishment which only survived by the skin of its teeth is the Lewis Textile Museum on Exchange Street in Blackburn (tel. 01254 667130). This was founded in 1938 by a textile manufacturer and is open free of charge on Tuesday to Saturday from 11 am to 4 pm. The machines on display include a Kay's flying shuttle, a replica of a Hargreaves' spinning jenny and what is described as a 'version' of Arkwright's water frame. Demonstrations of these and other machines in operation can be arranged by appointment.

Mill engines by their very sound and smell are well worth extended visits and there is a fine example at Ellenroad at Milnrow near Rochdale (tel. 07855 331074). A Steam Day operates on the first Sunday of each month from 12 noon to 4 pm. There are two engines, one named Victoria and the other Alexandra. These developed 3,000 horse power.

There is free parking, a picnic site, café, and bookshop, and there are often displays of old machinery, including spinning machines. Ellenroad was a large ring spinning mill and the engines needed a huge 220-ft chimney to provide the essential draught. The main mill has now gone but a visit to the engine house should not be rushed.

The Wigan Piers Experience (tel 01942 323666) tells three stories in one: the town as a mining centre, as a cotton town and as an important section of the Leeds and Liverpool Canal. From the pier a water bus crosses the canal and under a bridge to reach the steps leading to Trencherfield Mill (tel. 01942 777566) which was a spinning enterprise with a massive steam engine and a huge fly wheel from which belts of ropes led to the storeys where the machinery was situated.

Another most impressive engine is that at the Bancroft Mill in Barnoldswick (tel. 01282 865626). This was the last of thirteen mills built in the town. Opened in 1920, it finally closed in 1978. The only working part of the mill to survive are two boilers which provided steam to power the cross compound machine with a rope drive and generated 600 horse power. The mill chimney has also survived and is 120 ft high. There is viewing every Saturday between 11 am and 3 pm; and there are advertised steam days. There is plenty of parking, refreshments and a bookshop. When working at its peak there were 1,250 Lancashire looms and two of these are still operated and demonstrations are a feature of the present enterprise.

Lots of details of weaving in Burnley can be discovered on the bank of the Leeds and Liverpool Canal at the Weavers Triangle Visitors Centre on Manchester Road in the town

(tel. 01282 452403). It is open free of charge from Easter to the end of September and at other times by appointment. It is run by the Weavers Triangle Trust and donations are always welcome.

There is level access to the towpath and an area of disabled parking at Burnley Wharf. Weavers Triangle is a name devised in the 1970s to describe an area of this shape bounded by the Leeds and Liverpool Canal. During the heyday of cotton the most prosperous mill owners built their factories on the banks of the canal. Here there is an impressive sequence of weaving sheds and a few spinning mills, as well as warehouses, foundries, a school and domestic buildings. Here also is the historic Slaters Terrace which is a compact row of eleven houses above a canalside warehouse. During the summer a series of guided towpath walks along the Weavers Triangle is organised. Within the museum complex itself there is a Victorian schoolroom, a typical weaver's house, an exhibition of the Burnley Fair, and refreshments available in a mock-up of a Victorian parlour.

The building itself was housed in the former Wharfemaster's house and office. In the area there was the Oak Mount Mill which was built in 1830 and which worked until 1979. It was one of the last steam-powered mills in Burnley to close. The Weavers Triangle Trust now owns the engine house and chimney both dating from 1887. Helped by the Heritage Lottery Fund and the Science Museum Prism Fund, it is much as it was except the whole system is now run by electricity. The collection of photographs is very informative.

It is not possible here to mention in detail all the museums with a textile connection but one which should be mentioned is the Museum of Local Crafts and Industries attached to Towneley Hall in Burnley (tel. 01282 424213).

Over the county border in Cheshire, close to Manchester Airport, the National Trust-owned Styal Mill is also worth a visit (tel. 01625 445896). It covers the history of cotton from water to steam power.

Other places to visit in connection with the story of cotton include the ponds of the former print works at Foxhill Bank in Oswaldtwistle which are now part of an attractive local nature reserve; the lodge at the Barrow Printworks near Clitheroe where there is a pleasant footpath frequented by birdwatchers, botanists and butterfly hunters; the Oswaldtwistle Mills complex which has a nature trail and picnic site near the old mill lodge at Moscow Mill, plus in the same area a few remnants remaining of a railway line which linked a local coal mine to the boiler house of the mill. Here, too, is the Cotton Time Tunnel.

By far the best example of a working bobbin mill is at Stott Park near Lakeside close to the bank of Windermere (tel. 015395 31087). This mill, now carefully preserved by English Heritage, is open daily from 10 am to 5 pm and there are steam days from Tuesday to Thursday. The mill began to operate as early as 1835 and worked continually until 1971. It has been a museum since 1985, and was originally powered by a waterwheel, which still exists but was later replaced by a functional steam engine. Here there are massive arrays of pulleys and belts which drove the cutting, boring and finishing machines and the local woods provided ash, sycamore and especially birch. In the grounds there is a

coppiced ash woodland obviously dating to the period when the Lancashire cotton mills had an insatiable appetite for bobbins.

In this modern age, there is a demand to boast of operations which are the biggest and the best. In connection with the cotton industry, my personal choice has to be the Canal Mill complex at Botany Brow, Chorley. Thankfully it has been preserved as part of a shopping and antiques complex known as Botany Bay (tel. 01257 261220). The name Botany Bay refers to an area on the outskirts of the town, on the bank of the Leeds and Liverpool Canal and which can be seen from the M61 motorway. During the Industrial Revolution several mills operated in this area which was formerly known as Knowley Moss and was as such marked on a map dated 1734. The navvies working on the canal found their work hard and called this section Botany Bay because they thought it to be just as demanding as the penal colony being set up in Australia.

By 1816 this section of the cut had been completed and mills were operating, along with a network of warehouses set up to support them. In the 1850s, the dominant family in the area was the Smethursts and they owned a number of mills, including these at Botany Bay. They concentrated their main efforts on carded cotton but their prosperity was short-lived and in 1861 as the cotton famine reared its ugly head the Botany Bay mills closed. They re-opened in 1864 with the end of the American Civil War and soon the Botany Bay complex was operating 45,000 spindles and employing around 300 people. Nearby was the Hope Mill which was composed of several weaving sheds and a number of associated warehouses.

The mills of Botany Bay continued to function until the 1950s when, like many Lancashire mills, they were forced to close.

By 1830 there was a regular canal route for both passengers and goods linking Botany Bay with Wigan, Manchester and especially with the cotton port of Liverpool. An historian friend of mine described the Lancashire canals as 'cotton cuts' and it is hard to think of a better phrase. I have spent many years walking around these canals and you seldom walk very far before you encounter an area associated with the cotton trade.

The coming of the railway led to an increase in the efficiency of the transport system but the following of these land tracks is much more difficult. Either the old lines have been built over or those which are still operational are much more dangerous and therefore inaccessible to follow. In 1869 the Blackburn Railway opened and was routed through Botany Bay. There was a substantial viaduct and the line remained open until 1969. Apart from the cotton industry the railway also provided the essential coal delivery service needed for the boilers.

Botany Bay can be described as a mill shop and ones such as this have been a boon for cotton historians because it has meant that many of the old buildings which were so well built have survived. There is Barden Mill close to the canal in Burnley and also Oswaldtwistle Mills. The latter is still run by the Hargreaves family. This takes us back full circle to the inventor of the spinning jenny which was the starting point of the Lancashire cotton industry.

This last chapter has not been an after-thought but is an essential part of the history of cotton. I hope this book will

encourage those who read it to explore what remains, literally in the ground. There was once a Methodist preacher who responded to criticism which accused him of the excessive length of his sermons. His response was '*You would not complain about what I have put in but think about what I have had to leave out.*' This is certainly true in my case as I have traced our Cotton Industry from its origins to the present day. I would be interested to hear from any reader who has memories to add. All the research will be given to libraries and so will the correspondence which results from the publication of this book.

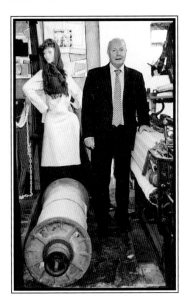

■ *Peter Hargreaves in his Time Tunnel.* ■

■ *The Oswaldtwistle Mills complex.* ■

Index

■